ON THE COVER: Musick's Ferry Inn at New Halls Ferry and the Missouri River was built in the 1850s and thrived for decades as a center of commerce and entertainment. Farmers stopped there for a night's rest, and folks from both sides of the Missouri River came to participate in the gaieties at the tavern or on the showboats. (Photograph by George Warren; Missouri Historical Society, St. Louis.)

IMAGES of America
OLD JAMESTOWN

Peggy Kruse

Photographs of extant historic places and homes
by Chandan Mahanta

ARCADIA
PUBLISHING

Copyright © 2023 by Peggy Kruse
ISBN 978-1-4671-6020-9

Published by Arcadia Publishing
Charleston, South Carolina

Printed in the United States of America

Library of Congress Control Number: 2023939492

For all general information, please contact Arcadia Publishing:
Telephone 843-853-2070
Fax 843-853-0044
E-mail sales@arcadiapublishing.com

Visit us on the Internet at www.arcadiapublishing.com

*This book is dedicated to the many good people,
past and present, of Old Jamestown, Missouri*

CONTENTS

Acknowledgments		6
Introduction		7
1.	Native Americans and New Arrivals	11
2.	Cemeteries, Churches, and Schools	23
3.	A Happening Place	41
4.	Hardworking Farmers	53
5.	Notables along the River	77
6.	Organizations and Businesses	93
7.	Early and Large Subdivisions	119
8.	Old Jamestown Association	123
Index		127

ACKNOWLEDGMENTS

First and foremost, thanks to Chandan "Chan" Mahanta for his goodwilled sharing of his photographic skills and time in taking many photographs that enrich this book.

Special thanks to Mary Lange Stellhorn, Jim Leighninger, Patty Murray, and Cindy Doner Winkler for their continuing support and assistance.

Thanks also to Susan Wehmer Kagy, Jesse Fister, Wesley Fordyce, Ginny Wehmer Borcherding, Linda Wehmer Wolfe, Michael Brandon, and Mary Lange Stellhorn for sharing photographs and information about their families.

Thanks to the Old Jamestown organizations that shared photographs and information: Black Jack Fire Protection District, Florissant Elks, American Legion Post 444, Pallottine Renewal Center, Jamestown New Horizons, and Salem Baptist Church.

And thanks to the good people who shared photographs from their institutions: Lauren Sallwasser at Missouri Historical Society; Gina Siebe at Historic Florissant, Inc.; Philip Skroska at the Bernard Becker Medical Library Archives, Washington University School of Medicine; Guinn Hinman at St. Louis County Parks; Amy Waters at the State Historical Society of Missouri; and Andrea Johnson at St. Louis County Public Library, Jamestown Bluffs Branch.

And continuous gratitude to God, from whom every family in heaven and on earth is named (Eph. 3:14-21), especially for my own wonderful and supportive family: Ray; Ken, Susan, Clayton, and McKenna; Kevin, Kelly, Brian, and David.

INTRODUCTION

In far north St. Louis County, Missouri, Old Jamestown is an area of rolling hills, beautiful river views and attractive subdivisions, many with lots that measure over three acres. It is a unique, fascinating area that has been overlooked because its early identity was meshed with other areas in St. Ferdinand Township, and its later identity was meshed with all areas of unincorporated St. Louis County. Names applied to parts of Old Jamestown during the early years include Coldwater, Patterson Settlement, the Sinks, and Jamestown.

Old Jamestown is in an unincorporated area of St. Louis County, Missouri, bordered by the Missouri River, Coldwater Creek, New Halls Ferry Road, and State Road 367/US Highway 67. As such, its planning and other municipal-type services are received from the county. In 2010, Old Jamestown became officially recognized as a CDP (Census Designated Place), which is treated as a municipality for statistic-collecting purposes.

Much of the Old Jamestown neighborhood is a very low-density, heavily wooded, and sinkhole-studded semirural environment. Situated along the bank of the Missouri River, it is just a few miles upriver from the confluence of the Missouri and the Mississippi and has a rich history dating back to ancient times.

According to Joe Harl, from the Archaeological Research Center of St. Louis, "Caves, springs, and sinkholes were often revered in prehistoric times, for they were thought to represent portals to the Underworld."

With only two miles separating the Missouri and Mississippi Rivers just north of Old Jamestown, it provided desirable connections from St. Louis and Florissant to St. Charles County, which is home to Portage des Sioux, an early military outpost, and the City of St. Charles, Missouri's first state capitol (from 1821 to 1826). It was also connected through St. Charles County locations to Alton, Illinois.

The name Jamestown was first used in this captivating description written over 200 years ago by Phinehas James when he advertised his development of 300 lots in an advertisement for "James' Town" printed in the *Missouri Gazette* on June 16, 1819:

> JAMES' TOWN Is situated on a beautiful bluff, on the southern bank of the Missouri River, six miles above its confluence with the Mississippi. Being situated on a bluff, it has the advantage of a firm rock shore, along which there are a number of the safest harbors for boats that I presume any other town on these waters can boast of; also, several seats for mills that so large a water course can form. Near the public square, there is a cave through which passes a large body of cold, sweet lucid water which I think could, without much expense be raised and conveyed to every part of the town. The earth after removing the virgin soil is admirably calculated for brick, and the rock along the river, which can be easily procured, is of the best quality, either for building or manufacturing into lime; sand for making brick and mortar can be procured without much trouble or expense. Behind this desirable situation lays the rich and flourishing country of Florissant or St. Ferdinand and in front (beyond that majestic river that sweep[s] along its base) is to be seen that fertile

bottom that intercepts the communication of those two splendid rivers (Mississippi and Missouri) which not only offers to the fancy a rich harvest of charms, but also to the town an abundant harvest of advantages. The situation of this town is so lofty and noble as never to offend by noxious fumes of putrid sickly air; and the eye has always presented to it, a beautiful and grand variety. In [conclusion], to give a more powerful and impressive idea of the value of the place, is but to observe that there are now about three hundred lots laid off, of which better than one sixth of that number are already disposed of, and most of the purchasers have promised to build on them immediately, which I consider as one strong, convincing proof of Jamestown having merit as an advantageous and desirable situation.

Phinehas James's wife at the time was Amy Jamison James, granddaughter of Eusebius Hubbard, who had come to Old Jamestown from Virginia and whose ancestors lived not far from the location of the historic Jamestown. Hubbard had died in 1818. Phinehas James's dream of a large community on the bluff did not work out, perhaps due to the collapse of land prices and recession around 1819, but the physical location of the Old Jamestown area was attractive to many travelers and inhabitants both before and after he posted his advertisement.

Artifacts have been found that suggest many nomadic Native American tribes passed through the Old Jamestown area over thousands of years. In addition, it is likely that a large, densely populated village associated with the Cahokia settlement in Illinois existed near the current Sioux Passage Park area from about AD 600 to 1200.

During the 1790s, following the Revolutionary War, Upper Canada vied with Kentucky and the Ohio Valley to attract settlers. Kentucky's appeal quickly wore out for those who had moved there, because their land was fraudulently taken by speculators. Some of those who had moved to Canada and Kentucky moved again to Old Jamestown and obtained generous land grants from the Spanish for living in "New Spain." Most of these newcomers were of British heritage and settled north of Coldwater Creek. By the early 1800s, almost all the land in far north St. Louis County had been granted to these new arrivals.

German farmers discovered Old Jamestown in the mid-1800s. Prices for land increased fivefold between 1853 and 1876. Nevertheless, many German settlers were able to buy their own—sometimes fairly large—farms. John Kohnen's memory of growing up in the area provides a description of a typical farm in the 1900s, as reported in *The Big Tree—Memoirs of the Kohnen Family* by John Kohnen and Patricia Kohnen Goldkamp:

> Growing up on what was known as a truck farm, nearly all of our needs were met by crops and essentials raised on the farm. Other than flour, sugar, salt, yeast, and coffee, nearly everything else was home grown. Cash crops included potatoes, sweet potatoes, corn, sweet corn, wheat, alfalfa, tomatoes, turnips, and horseradish. Garden crops included onions, beets, carrots, peas, butter beans, string beans, okra, pickles, strawberries, and grapes. Fruit trees included peach, apple, and cherry. A cow provided milk, hogs were raised for meat, chickens provided eggs and meat. Mules were the draft animals that provided the only assistance other than human labor required to accomplish whatever was needed to be done. We loved all the animals but the mules were always special, at least they were the only animals to be given names, other than the dogs. Everything that was raised on the farm was either sold, fed to the animals, eaten, canned, or preserved and stored for the winter. By the fall of the year, the shelves in the basement were lined with mason jars filled with everything that a bountiful harvest provided. Many a day was spent stirring the old copper kettle over an open fire while the apple butter or ketchup cooked to perfection. Butchering days in the winter were almost a holiday as the neighbors got together during the day doing the necessary chores and the men played pinochle and drank port wine in the evening. Nearly all the farmers made their own wine and during Prohibition most made their own beer.

Making wine for your household was legal during Prohibition; making beer was not.

Like the Native Americans and European arrivals before them, the wealthy recognized the unique environment of the Missouri River bluffs. Those who could afford river estates began coming to Old Jamestown in the 1920s, 1930s, and 1940s as roads and cars made it easier to travel farther from the centers of commerce. The largest estates were located on the west at Musick's Ferry (Desloge), in the center near Sioux Passage Park (Curlee), and on the east at the site of Phinehas James's plan for "James' Town" (Mesker). Old Jamestown bluffs are some of highest Missouri River bluffs in St. Louis County. The area avoids flooding because of the bluffs and because floodwaters go to the floodplain between the Missouri and Mississippi Rivers just north of Old Jamestown.

Across the years, Old Jamestown residents have also been connected to national experiences, including Native American travels, the Revolutionary War, slavery, the Civil War, and Prohibition. Three known Revolutionary War soldiers are buried in Cold Water Cemetery: John Patterson Sr. (died in 1839), Rev. John Clark (died in 1833), and Eusebius Hubbard (died in 1818), as well as soldiers who fought in the War of 1812, the Seminole War, the Civil War, the Mexican-American War, World Wars I and II, the Korean War, and the Vietnam War. Rev. John Clark was the first Protestant minister to preach west of the Mississippi. Several churches got their starts on the cemetery grounds.

In 2020, Old Jamestown's 14.93 square miles had 19,790 residents living in 7,010 homes. Residents were diverse and well educated, with a median household income of $97,341. To learn much more about many of the topics in this book, as well as the sources used in the research behind the text, check out *Old Jamestown Across the Ages: Highlights and Stories of Old Jamestown, Missouri*, by Peggy Kruse, which is available on Amazon and viewable as a PDF on the Old Jamestown Association website at www.oldjamestownassociation.org.

One
NATIVE AMERICANS AND NEW ARRIVALS

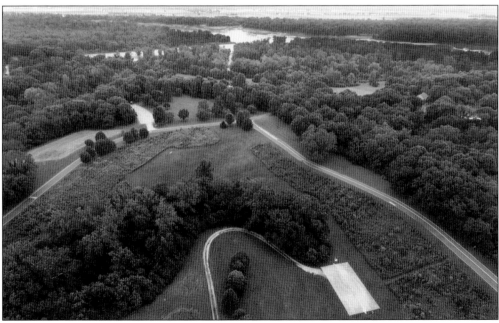

"Grandfather Great Spirit. . . . Teach us to walk the soft earth as relatives to all that live," says a Sioux prayer. Native Americans and then later arrivals used the unique characteristics of the Old Jamestown area as travel routes. This photograph of Sioux Passage Park shows the Missouri River at the top. At the top left is Pelican Island, which is separated from the mainland by the Car of Commerce Chute. (Photograph by Chandan Mahanta.)

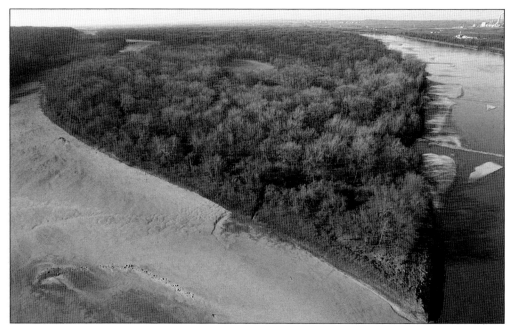

The above photograph is a closeup of Pelican Island and the Car of Commerce Chute at a time of very low water. The smokestacks across the river are near Portage Des Sioux on the Mississippi River. Significant prehistoric sites in Old Jamestown include a large Mississippian site (AD 1050–1400) in the Sioux Passage Park area thought to be connected to the Cahokia Mounds. In 1927, a huge whisky and beer plant on Pelican Island was raided by the chief prohibition officer, and the facility was dynamited. The 1857 topographical map below shows the Old Jamestown boundaries of the Missouri River, Coldwater Creek, and Musick Ferry Road as well as the town of Jamestown, begun in 1819 but never completely developed. (Above, photograph by Chandan Mahanta; below, Library of Congress.)

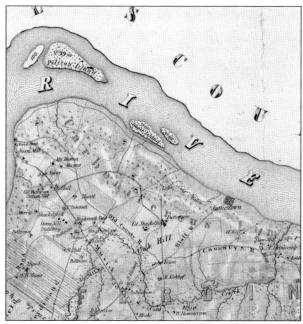

After the 1803 Louisiana Purchase, a major issue surrounded whether the United States government would recognize land titles obtained from the French and Spanish by the earliest settlers. In 1805, Congress declared that persons who inhabited and cultivated the property and had a warrant received on or before 1800 were considered to have complete claims and were confirmed. In the 1790s, Sarah Bishop James had come from North Carolina with her seven children. She obtained a grant on the river, and four of her sons (Benjamin, Cumberland, Morris, and James) obtained other grants in Old Jamestown. Sarah's daughter Sara married Ebenezer Hodges, and her daughter Rebecca married Guy Seeley. As early as 1805, Sarah James had a ferry operation from her property to St. Charles County. These documents are from the northwest portion of Old Jamestown in the 1846 Julius Hutawa Atlas. (Both, Missouri Historical Society, St. Louis.)

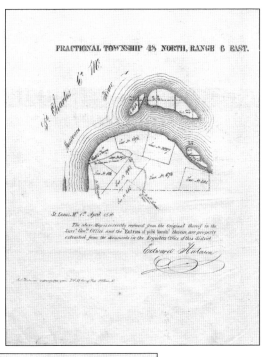

FRACTIONAL TOWNSHIP 47 & 48 NORTH, RANGE 7 EAST.
Confirmed Claims.

No. of Surv.	Names of Persons to whom confirmed	Acres	No. of Surv.	Names of Persons to whom confirmed	Acres
52	Vincent Carrico	425.85	1907	Morris claims	340.25
104	John Brown	510.40	1909	William Massey and Ezekiel Land	
107	David Brown's rep.s	340.22		(that part of this tract which lies within	
112	Seth Chetwood	340.22		the bounds a, b, c, d, cont.g 469 acres was	
113	Richard Chetwood	519.46		purchased by the U. States for the use of	
114	Isabelle Chetwood	340.22		the Belle Fontaine Old Cantonment, which	
115	John Basye and Wm. Burk or Burch	341.64		has been abandoned for many years & the	
141	John Graham	400.67		land sold to individuals in 1836)	850.70
155	Jacques St. Vrain and widow Riquche	340.28	1959	Antoine Soulard & Jacques de St. Vrain	
209	John Lard	340.28		(this confirmation is for 2250 arpens equal to	
240	William Patterson	510.40		1761.97 acres, but by a special decision of the	
225	Peter Derbigny and Jos. Hart, rec. of S.B. Chouteau	340.23		Attorney General of the U. States dated the	
329	Pascal L. Cerre and Louis Brazeau	680.56		8th April 1824 this claim is good according	
360	Cumberland James	340.28		to the Spanish Survey, which contains the	
361	Ebenezer Hodges	425.35		quantity here noted)	3126.32
390	Ira Nash	276.00	1960	Morris James and Charles Dejarlais	256.21
398	Lydia Buck	467.88	2007	Susannah Duncan	195.10
474	John N. Seeley	340.12	3062	Arend Rutgers (confd. and special act of	425.35
934	Guy Seeley (by survey this claim has been extended southward so as to include entry No. 784 & part of Entry 791 as represented by the letters e, f, g, h	574.32	3023	Benjamin I. thomas or legal representation confirmed by the Act of Congress of 4th July 1836. this survey includes entries No. 808	
1012	Sol. B. Hart and Elisha Herrington	640.00	1691, 1839	2439 & a part of No. 791 (and all lands westward into Range 6 East	336.98
1707	Pierre Chouteau jun.r	520.00	3097	Gabriel Lacroix or leg.l rep.s per Com.r's decision No. 150	338.65
1840	Jacques St. Vrain	765.63			

Unconfirmed Claim.

B. Dennis Cavanna. (Spanish survey executed 25th Apr. 1798 in virtue of a decree of the 12th May 1797). 191.00 arpens

New Madrid Locations.

No. of Certif.	No. of Surv.	Names of persons to whom granted	Acres	No. of Certif.	No. of Surv.	Names of persons to whom granted	Acres
No. 9	2470	Francis Lessieur	160.00	No. 147	2482	John & Hudgens assignee of John Culbertson, who was ass.e of Matheney	170.14
10	2471	same	160.00	151	2495	William Robertson	640.00
49	2713	Amable Guyon	160.00	288	2697	Robert McCoy	160.00
62	2562	John Baker jun.r	176.00	394	2771	Nicholas Davis	640.00
101	2448	Benjamin Rogers	640.00				

Lands appropriated for the use of Public Schools.

For T. 47 N. R. 7 E. { S.E. fr. gr. sec. 9 containing 162.00 acres
Fract. sec. 16 " 347.10 } aggregate
S.E. gr. 19 " 160.00
N.E. fr. gr. sec. 17 " 136.12 } 795.22 acres

For T. 48 N. (South of Mo. riv.) R. 6 E. — S.E. gr. sec. 11 160.00

For T. 47 N. (South of Mo. riv.) R. 8 E. — N.W. gr. sec. 33 160.00

— School lands within congr. T. 47 R. 7 aggregate 1115 acres

This list of confirmed claims shows many of the Old Jamestown land-grant holders, including many James and Hodges family members. It also includes grantees whose property was outside of the Old Jamestown boundaries but nearby. At the top of the page is Vincent Carrico, whose grant was adjacent to Old Jamestown on the east; Vincent also later bought the John Brown property. The Cerre family had been in the middle Mississippi River valley area since the 1750s. One Cerre woman married Auguste Chouteau, the founder of St. Louis, and another, Julia, married Antoine Soulard. Soulard surveyed a large portion of St. Louis in its early settlement days, including the Old Jamestown area. Julia donated the land that became Soulard's Farmers Market to the City of St. Louis. (Missouri Historical Society, St. Louis.)

Grantee Guy Seeley's property was directly across the Missouri River from Little's Island in St. Charles County, where Native Americans portaged across the land between the rivers and connected with a Great Trail that ended at St. Louis. Seeley's home was a log cabin, which was enlarged over the years. This is what the home looks like now. When Gen. James Wilkinson came to the area after the Louisiana Purchase to select a site for a military fort and Native American trading post, he was a guest in the Seeley home. Wilkinson chose the site of Fort Belle Fontaine just east of Old Jamestown. In later years, John Mullanphy, Missouri's first millionaire, bought the Guy Seeley property and deeded it to his youngest daughter, Eliza, who married James Clemens Jr., Mark Twain's second cousin, in 1833. (Both photographs by Chandan Mahanta.)

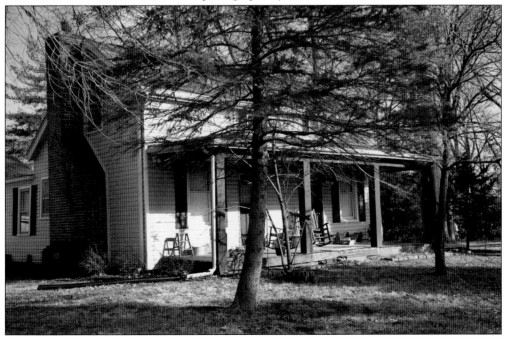

Capt. Edmund and Rachel Godfrey Hodges, both direct descendants of *Mayflower* passengers, were born and married in Massachusetts. After the Revolutionary War, they moved to Vermont, then Canada, then Old Jamestown. Captain Hodges and four of his sons (Gilbert, Samuel, Daniel, and Ebenezer) obtained land grants in Old Jamestown for a total of 1,731 acres. His daughter Rachel married Benjamin James, who had a grant of 805 acres. His daughter Julie married Charles Desjarlais, who had 255 acres. Gilbert was married to Sara James (daughter of Sarah James, who held an adjacent land grant of 340 acres). Ebenezer's wife, Mary, was probably the sister of John N. Seeley, who had 681 acres. Six of these grants (2,110 acres) were along the Missouri River or the Car of Commerce Chute. According to property records included in Kevin W. McKinney's 2012 book *Captain Edmund Hodges and His Descendants: The Hodges Family of the Niagara District of Ontario, Canada*, Ebenezer's estate was "at the portage of the Sioux" and included 300 acres on the headwaters of "Hodges Mill Creek," most likely today's "Mill Creek" in Sioux Passage and Briscoe Parks. (Photograph by Chandan Mahanta.)

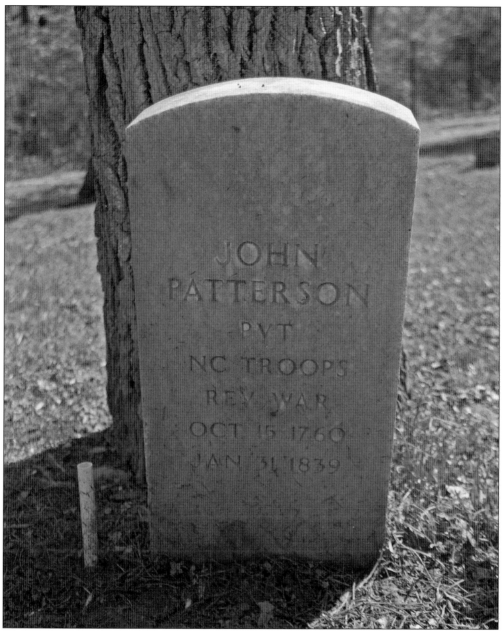

Members of the Patterson family, who came to the continent in the early 1700s, were among the first settlers of British origin and one of the first Protestant families in St. Louis County. The Patterson Settlement, which encompassed almost all of what is now Old Jamestown, was 10,000 acres, although only about 2,000 acres (acquired through land grants to John Jr. and William and later family purchases) were actually owned by members of the Patterson family. John Patterson and his first wife, Keziah Hornaday Patterson, had 12 children. After Keziah's death in 1809, John married the widow of Joseph Jamison, Sally/Sarah Hubbard Jamison, who had 12 children of her own. Together, they had one additional child, David. Sally was born in Henry County, Virginia, in 1766, a daughter of Eusebius Hubbard, who was a Revolutionary War veteran. Sally died in 1832. John died in 1839. (Both photographs by Chandan Mahanta.)

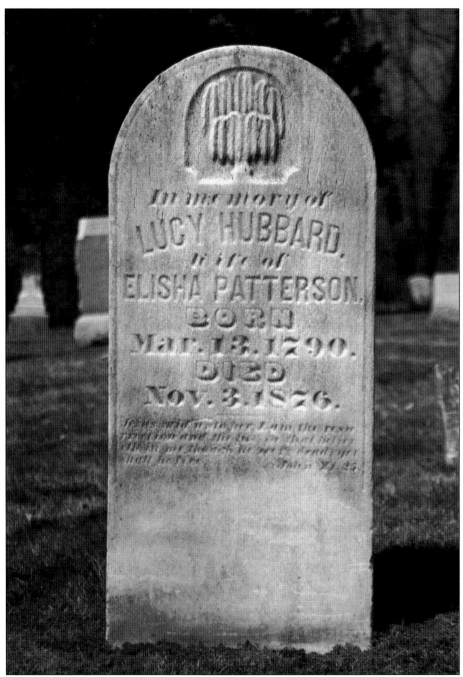

Elisha Patterson, born in 1784 in Orange County, North Carolina, was the second son of John and Keziah Patterson and a significant presence in Old Jamestown. He came to the area with his parents in the late 1700s and served in the War of 1812 as a sergeant in Capt. James Musick's militia company. Elisha married Lucy Hubbard, granddaughter of Eusebius and Amy Durrett Hubbard, in January 1806. Elisha provided sites on his property at New Halls Ferry and Patterson Roads for a school and the new family church, which had been in Cold Water Cemetery. (Photograph by Chandan Mahanta.)

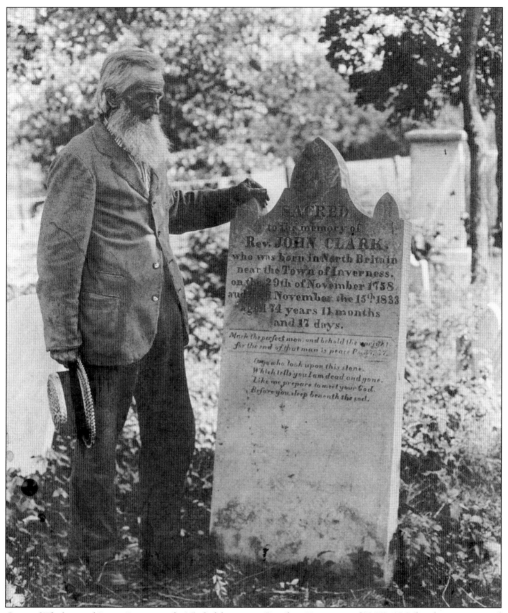

One of Elisha and Lucy Patterson's 15 children was Sanders Patterson (1825–1906), who is pictured here in Cold Water Cemetery with the tombstone of Rev. John Clark, the first Protestant preacher to hold services west of the Mississippi. Reverend Clark had officiated at Sanders's parents' marriage in 1806. Elisha's commitment to his faith and to Reverend Clark continued throughout his life. Reverend Clark died in 1833 in the home of Elisha and Lucy. Following his father's precedent, Elisha ensured his family's success by providing property and houses for each of his children. (Salem Baptist Church.)

In the late 1700s, the Spanish granted David Brown the ground on which the Tunstall-Douglass House now stands. The land was later owned by sons of John Patterson, then Elizabeth B. Tunstall, then Nicholas Blacklock and Margaret Patterson Douglass. Douglass had the home constructed by slave labor with bricks kilned on the property. In 1885, Herman C. Rosenkoetter purchased the home; by 1910, he was farming about 300 acres, specializing in fruit. Oscar and Velma Hammer purchased the home in 1940 and established Old Halls Ferry Stable. The home was severely damaged by fire in 1992 and again in 2014. As shown in the photograph, much of the facade has, sadly, been dismantled. (Photograph by Chandan Mahanta; Old Halls Ferry Stable.)

Patterson, John	Saint Louis	St. Louis	Request for transportation for Patterson to New Albany, Indiana; has been in Alton Prison 9 months; wishes to return to family in Tennessee	03-02-1865	F1382		
Patterson, John	Saint Louis	St. Louis	Special Orders 281-II extending limits of parole to loyal states; bond sureties have consented; he will report monthly by letter or in person	10-31-1864	F1382		
Patterson, John	Saint Louis	St. Louis	Special Orders No. 18-III releasing prisoner on oath and bond, to remain in St. Louis County and report in person every 2 weeks	08-20-1862	F1382		
Patterson, John H.	Saint Louis		Oath	08-26-1862	F1382		
Patterson, John H.	Saint Louis		$2,000 bond; restricted to St. Louis county; security William Patterson	08-26-1862	F1382		
Patterson, Jonathan; Boyce, W. S.	Saint Louis		Request that Patterson have Ste. Genevieve added to the bounds of his parole; Patterson released per Special Order 48, to remain in St. Louis County; written from Valle Forge (St. Francois County implied); parole of honor document of both men included	01-07-1863	F1584	0094	845
Patterson, P.; Patterson, Joe; Harris, Solon; Harris, Jim; Myers, Montgomery; Hyatt, Joe; Tunstall, Rob; Hurnes, James; Evans, Watt; Patterson, Ed; Douglass, Nic; Ferguson, James; Ferguson, Charles; Lewis, [unknown]	Saint Louis	St. Louis	List of disloyal persons.	08-25-1862	F1587	0206	1894
Patterson, R. M.; Lee, V.; Douglas, Richard; Bowen, J. C.; Allen, Joseph; Depp, Thomas; Bledsoe, William;	Saint Louis		Prisoners ordered to provost marshal's office; notes military rank of many	06-18-1863	F1598	0448	5188

There were slaves in Old Jamestown for many years before the Civil War, some of whom came with the original land grantees. The 1860 Slave Schedules related to Old Jamestown show 148 slaves and 31 slaveholders. Missouri was admitted into the Confederate States of America in November 1861. Only the Confederate-sympathizing portion of the Missouri government seceded. The loyal Union portion of the state remained a part of the United States. Martial law (military rule) was declared in St. Louis on August 14, 1861, and a provost marshal was in charge. Citizens would report their neighbors as suspected secessionists to the provost marshal, who would then investigate and arrest people. This page is from Missouri's "Union Provost Marshal Papers: 1861–1866," which include Old Jamestown residents. This image is from the Missouri Secretary of State website, Missouri Digital Heritage (mo.gov).

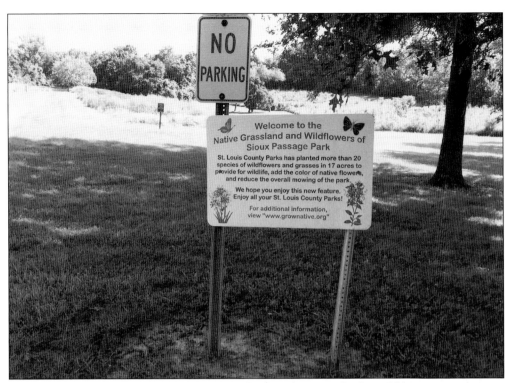

In recent years, St. Louis County Parks Department has gone back to Old Jamestown's roots by planting native wildflowers and grasses on 17 acres in Sioux Passage Park. In doing so, the department joined several Old Jamestown residents (Mahanta, McNair, and Mesker) who own large lots on the Missouri River and have transformed their yards with native plants. It takes a lot of effort and several years, but the native plants gradually become established and provide many varieties of wildflowers and warm-season grasses. June and July are peak bloom times, and the flowering plants provide pollen for bees. In winter, the dry grasses and seed heads are not only aesthetic but also provide wildlife with food and habitat, proving that the prairie is an ecosystem. (Above, photograph by Peggy Kruse; below, photograph by Chandan Mahanta.)

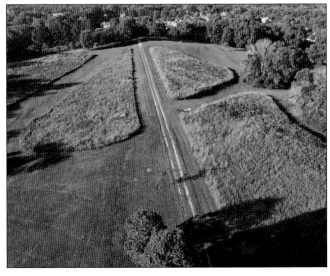

Two
CEMETERIES, CHURCHES, AND SCHOOLS

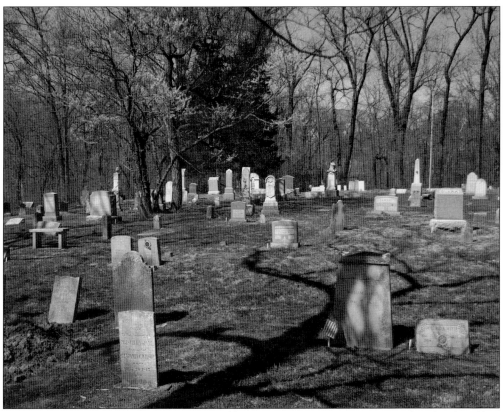

Cold Water Cemetery, located at 15290 Old Halls Ferry Road, is considered to be the oldest Protestant cemetery still in use west of the Mississippi River. Three known Revolutionary War soldiers are buried there, as well as soldiers who fought in the War of 1812, the Seminole War, the Civil War, the Mexican-American War, World Wars I and II, the Korean War, and the Vietnam War. (Photograph by Chandan Mahanta.)

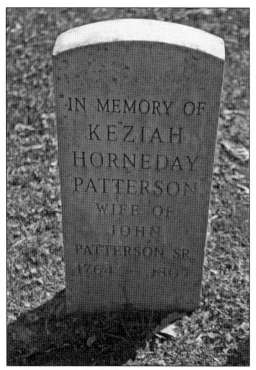

Cold Water Cemetery began as the Patterson family burial ground. The first burial may have been John Patterson's first wife, Keziah, in 1809, but the first documented burial at the cemetery was that of Patterson's second wife's father, Revolutionary War patriot Eusebius Hubbard, who was born in 1744 and died in 1818. The Patterson family was one of the first Protestant families and among the first settlers of British origin in predominantly French Catholic St. Louis County. The cemetery is now the property of the Missouri State Society Daughters of the American Revolution, who maintain it and host a traditional Memorial Day ceremony. (Both photographs by Chandan Mahanta.)

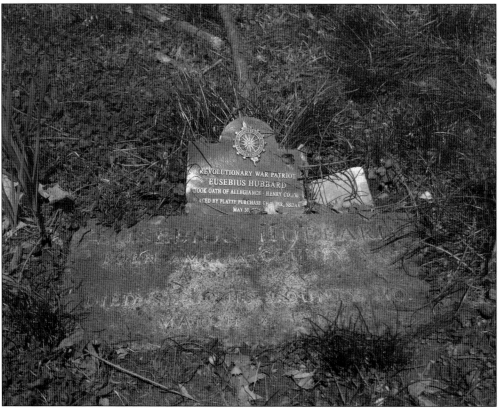

In 1886, newly freed men purchased a half acre of land to be used as a cemetery at 13711 Old Halls Ferry Road. New Coldwater Burial Ground was one of the few graveyards in Missouri both owned by and reserved for African Americans. An adjacent tract had been purchased by former slaves in 1868 for $1 to be used as an African American church and school, both of which no longer exist. The last burial was of Frazier Vincent, who died in 1963 and was the son of formerly enslaved people. Vincent had many jobs over the years but was primarily a farmer. His sons James and Frazier both served in World War II. The cemetery is on the Black Jack side of Coldwater Creek, and the City of Black Jack took over responsibility for maintenance of the cemetery and held a rededication ceremony in 1995. (Both photographs by Chandan Mahanta.)

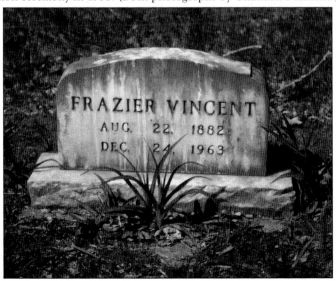

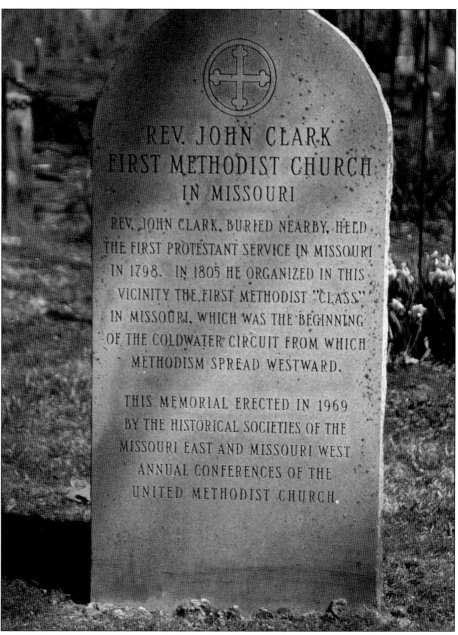

The early churches in Old Jamestown were Protestant (Methodist, Baptist, and Presbyterian) and had their beginnings on the Cold Water Cemetery grounds. About 1797, John Patterson Sr. and his family arrived in the Coldwater Creek area from the Carolinas. Despite being banned under Catholic Spanish rule, the Pattersons retained their Protestant faith through the services of a Methodist (later Baptist) minister, Rev. John Clark, who held services in their homes. After the United States purchase of the Louisiana Territory, the Pattersons helped finance and build a church and a school in Cold Water Cemetery for their family and neighbors. In 1809, Cold Water Church separated from the organized Methodist church and continued as an independent Protestant church. The church became affiliated with the Friends to Humanity, a Baptist denomination that abhorred slavery. (Photograph by Chandan Mahanta.)

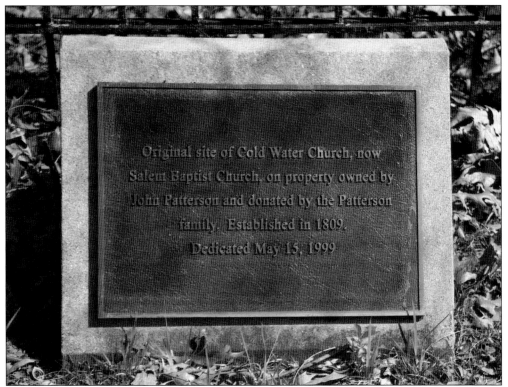

After a log church on the Cold Water Cemetery grounds burned down, in 1832, the church commissioners met to plan the building of the new church and promised "at all times to regulate the burying ground." The second church, Cold Water Church/Union Meeting House, was built on the site of the original church and shared by the Methodists, Baptists, and an early Presbyterian congregation. The congregations maintained the cemetery site for many years. In May 1870, a list of subscribers obligated themselves to pay dues "for the purpose of enclosing with a plank fence the Burying Ground at old Cold Water Church." It is believed the second church also burned down. (Both photographs by Chandan Mahanta.)

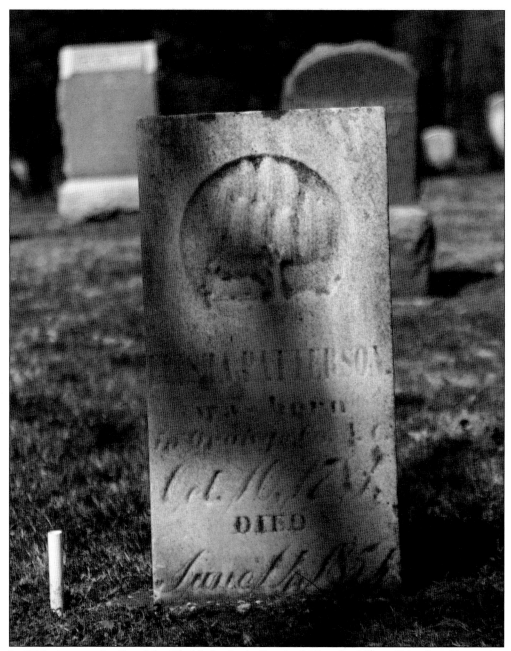

In 1839, six years after Rev. John Clark's death, the Baptized Church of Christ Friends to Humanity, which had been organized at Cold Water the year after his death, ceased to exist. On September 23, 1841, Salem Baptist Church of Cold Water was organized by the old churches of Union and Cold Water. The two Baptist factions that had split over slavery reconciled, and the name Salem, meaning peace, was chosen to represent their reconciliation. Those who organized the church came from many of the families buried in Cold Water cemetery: Assenath Piggott Patterson (wife of William Patterson), Cumberland James, Gilbert James, Keziah Patterson James, Elizabeth Blackburn, Edward Hall, Solomon Russel, Ann E. Henley, Sarah Hume, Eveline James, Ellender A. Russel, and Frances Monroe. (Photograph by Chandan Mahanta.)

This program is from the 150th anniversary of Salem Baptist Church in 1959. Later, a bit of personal parishioner history appeared in the church's July 1977 *Lamplighter* newsletter: Edward Charles Hume (1898–1977), son of Elisha Patterson Hume and Mary Lindemann Hume, was born in a log house on the bluff of the Missouri River near the corner of Shackelford and New Halls Ferry Roads. Edward attended the Coldwater/Salem church all his life. In 1916, he walked several miles through the snow to be baptized in the little, white-framed Salem Baptist Church, where he was a faithful member for 61 years. His three sons were deacons, and all family members were active members. Edward and his wife, Margaret, boarded schoolteachers and the men who were putting in the dikes on the Missouri River. They shared their home and their meals with many, many people through the years. Ed's smile, twinkling eye, and witty replies—as well as his helping hands—were greatly missed. (Salem Baptist Church.)

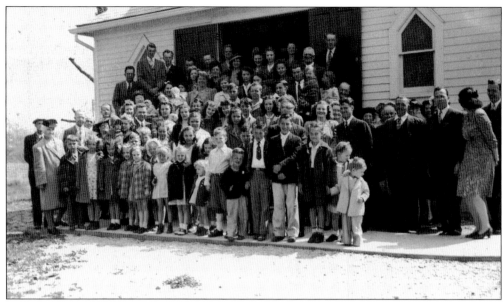

In 1885, members of Salem Baptist and the Methodist church began using the James School (later named the Brown School) on Old Jamestown Road near Carrico. This worked well until the 1900s. In 1911, a new Salem Baptist Church was constructed across Old Jamestown Road from the Brown School. Two rooms were added in the back in 1948. In 1959, the new church, which included an auditorium, a nursery, and other rooms, was dedicated. In 1970, bonds were issued to erect the present educational building. These photographs are from the original building. The above photograph shows families gathered in front of the church, possibly before 1943. The below photograph shows teenagers at a Sunday school or Vacation Bible School class about 1955, with Aurelia Thompson Wehmer standing at left. (Both, Salem Baptist Church.)

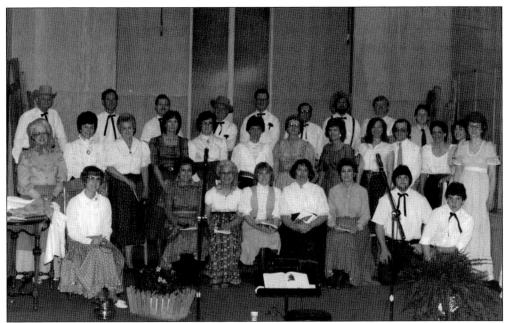

Salem Baptist Church continued to be an active presence in the Old Jamestown community and beyond. The church's Sunday school was organized in 1884. In May 1948, the first Vacation Bible School was sponsored. The Baptist Training Union was organized in 1926. The Women's Missionary Union was organized in 1913; it later became dormant but was reactivated in 1946. The above photograph features a group of Salem Baptist Church parishioners who performed the musical *Bright New Wings* in the 1980s. Below, Wanda Smith and Betty Leach are serving in the downstairs kitchen of the original church on Old Jamestown. (Both, Salem Baptist Church.)

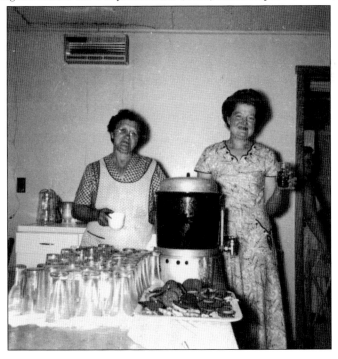

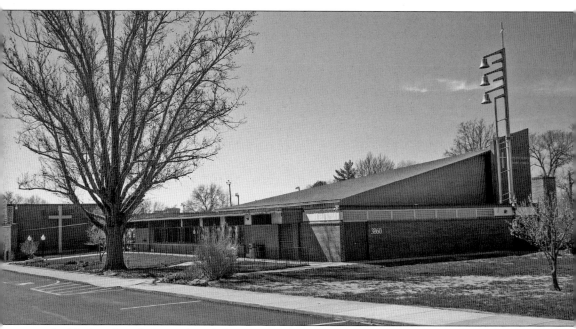

Archbishop Joseph Ritter founded Saint Angela Merici Parish, located at 3860 North Highway 67, in June 1962. Fr. Paul Kersgieter was appointed the first pastor. The parish opened with about 200 member families. The first Masses were held in the rectory until the church was completed and dedicated in June 1964. The first four rooms of the school were opened in 1965 with 163 students. In June 1980, the Buckley Montine Center was dedicated, and the expansion continued with the opening of additional classrooms and library. In the fall of 1995, portable classrooms were added to house a kindergarten. In July 2005, the vision for the St. Louis Archdiocesan North County Deanery was enacted, and St. Angela Merici welcomed its newest members from the closed Transfiguration and St. Christopher parishes. St. Angela now consists of over 1,200 member households. (Photograph by Chandan Mahanta.)

St. Andrew UMC, located at 3975 North Highway 67, was established in 1965. Five families from the neighboring St. Mark's and North Hills Methodist Churches were commissioned to serve in the new congregation. Between April and June 1965, many meetings were held at the parsonage in Cross Keys Apartments. During these meetings, the name of the church was discussed. Suggestions included Shoveltown Methodist Church, based on the location of the new church property—Shoveltown was the name of the small community surrounding the new church at Old Halls Ferry and Highway 67. Finally, the name St. Andrew was chosen in honor of the first apostle to follow Christ. Twenty-four people attended the first service in Black Jack Elementary School, where services were held until the new building was completed. St. Andrew continues to be one of the most ethnically and culturally diverse congregations in the Missouri Conference of the United Methodist Church. The diversity of pastoral leaders, staff, and laity is at the core of the unique call of St. Andrew to "make disciples for the transformation of the world." (Photograph by Chandan Mahanta.)

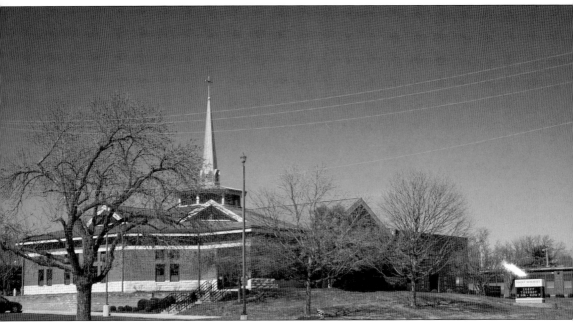

St. Norbert was one of the parishes founded as the population grew in nearby areas. In April 1966, ground was broken for the new church, and by September 1966, 559 families were registered. Mass was offered for the first time in the new church in September 1967. In 1969, land was purchased for athletic fields, and in 1974, there were 900 families registered. After Barrington Downs was developed with more than 800 homes, parishioners saw the need for a school, and in 1988, St. Norbert School opened with kindergarten, first, second and third grades – one grade was added each year. In 1992, with 1,400 member families, the new church building was dedicated. The original church was renovated into a parish hall with additional classrooms in 1994, and in June 1995, St. Norbert School had its first graduating class. (Photograph by Chandan Mahanta.)

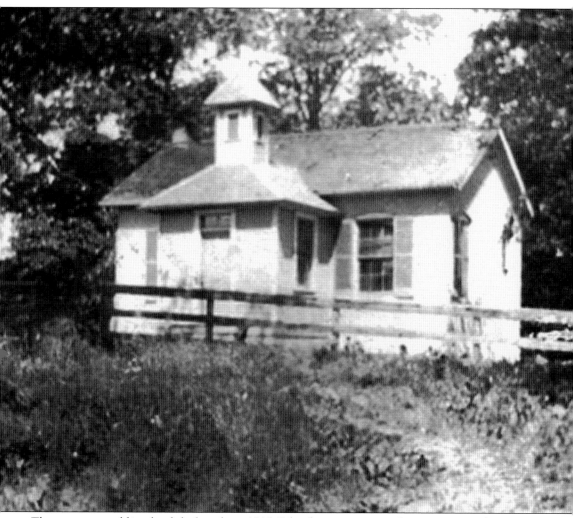

There were no public schools before about 1845. Schools were a matter of private contract between a teacher and a few heads of families. When public school districts began in the mid-1800s, Old Jamestown had three: Brown, Cold Water, and Vossenkemper. Old Brown School, located at 19719 Old Jamestown Road, was constructed around 1860 on land donated by William James, grandson of landholder John N. Seely. It was called the James School until the 1890s. Its name was changed over the years from James to Douglas to Brown as teachers wished to honor their families. In 1949, Elm Grove School District on Highway 67 reorganized as a six-director district and became Hazelwood School District, which in 1950 annexed the Brown School. The building was then used by Salem Baptist Church for a parsonage and is now a private residence. (Susan Wehmer Kagy.)

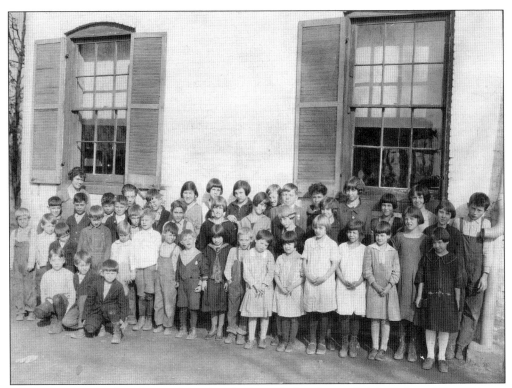

These photographs show Brown School students, including Louis, Ralph, Bob, and Jim Wehmer (sons of Louis and Aurelia Wehmer), around the 1920s. Sisters Mary and Virena Douglas, who lived in the Tunstall-Douglass House on Old Halls Ferry, taught at Brown School in the late 1800s. Mary was there first. Virena became the teacher when Mary married Henri Chomeau. Virena then married Henri Chomeau after Mary died in childbirth in 1882. Here is a sample of the annual teacher salaries at Brown: $855 in 1911; $900 in 1923; $1,035 in 1932; $765 in 1933 (the salary dropped as the Depression deepened); $1,000 in 1941; and $1,620 in 1949. (Both, Linda Wehmer Wolfe.)

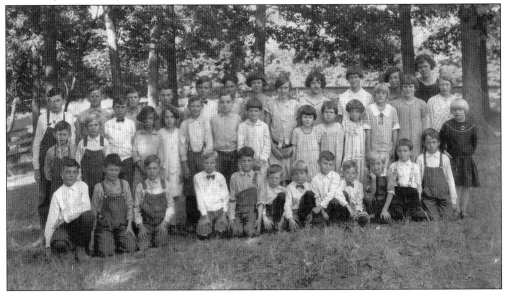

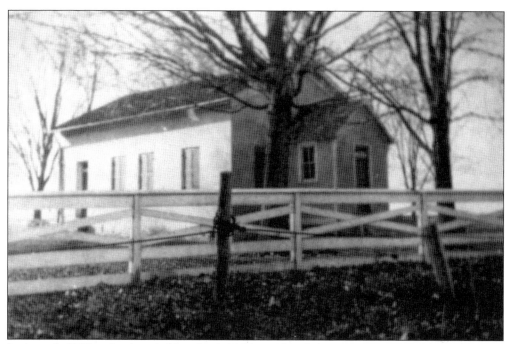

In the early 1800s, school was held in the Cold Water Church/Union Meeting House in Cold Water Cemetery. In response to concerns about having a school in a cemetery (as well as overcrowding), Elisha Patterson erected a school building in the southeast corner of his own property at New Halls Ferry and Patterson Roads. In 1859, Elisha's family built a new school approximately one quarter mile north. The historic building at 15875 New Halls Ferry Road sits in front of Hazelwood Central High School and is currently owned and maintained by the Hazelwood School District. These photographs were taken around 1913. (Both, Historic Florissant, Inc.)

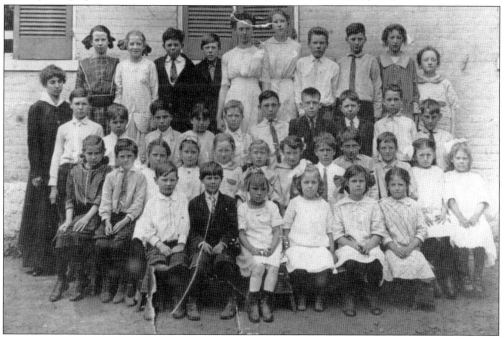

On July 28, 1852, Jacob and Lydia Veale deeded a quarter acre of land "or more, if absolutely necessary," for school purposes. There was a restriction on the gift, which stated that the land must house a school within two years, or it would revert to the donors. On December 30, 1867, Henry Vossenkemper and his wife conveyed this same tract to the school district, so the land probably reverted to the Veales, and they transferred it when they sold the rest of their ground to Vossenkemper. A one-room school was built. Later, a second Vossenkemper School was built at 6200 North Highway 67—a big two-roomer on the southwest corner of the highway and Robbins Mill Road. After joining the Hazelwood School District, Vossenkemper School held its last graduation in June 1954. (Historic Florissant, Inc.)

Barrington Elementary School (above) on Old Halls Ferry Road was built in 2004 for children moving into new housing developments within the Old Jamestown area. The school contained students from kindergarten to sixth grade. Due to increased population growth and Hazelwood School District moving into a more middle-school format, the sixth grade moved to the newly built Hazelwood North Middle School (below) on Vaile Avenue in 2008. Barrington Elementary currently holds 350 to 375 students with departmentalized third through fifth grades; this means that in these grades, one educator teaches math gradewide, another teaches reading, and one teaches science and social studies. The school has a very active family and community committee. It has a yearly fall festival and celebrates—with great turnout—National Walk to School Day. (Both photographs by Chandan Mahanta.)

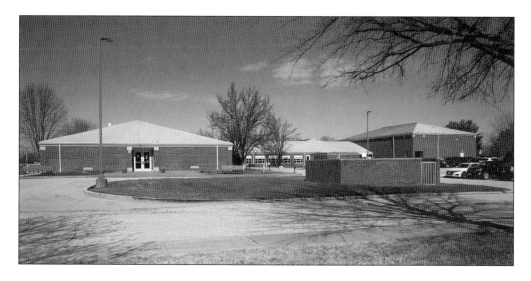

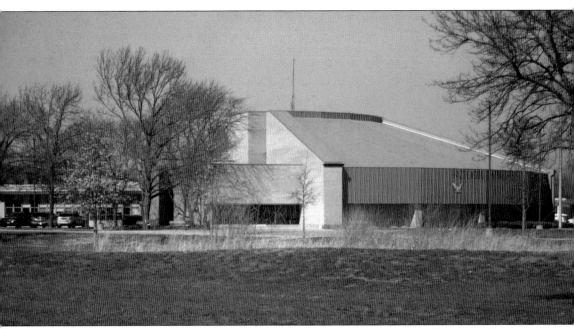

Hazelwood Central High School is on the same property as the historic Cold Water School. The first Hazelwood High School was completed in 1954 at 1865 Dunn Road. During the early 1960s, as farmland became subdivisions, more students enrolled in the district, and the new Hazelwood High School was established in 1966 on New Halls Ferry Road. It was the only high school in the district and quickly became overcrowded as the baby boomers reached high school. The rapid growth of the district proved too much even for a building of Hazelwood's size, and in 1970, the school was forced to split the student body into two shifts, with one shift attending from 6:30 a.m. to 12:30 p.m. and one from 1:05 p.m. to 7:05 p.m. Later, overlapping shifts were used with a one-hour start-time difference, because they could not get 100 percent of the students in or out of the building at one time. In 1977, with the opening of two more high schools, Hazelwood East and Hazelwood West, Hazelwood Central returned to a conventional schedule. (Photograph by Chandan Mahanta.)

Three
A Happening Place

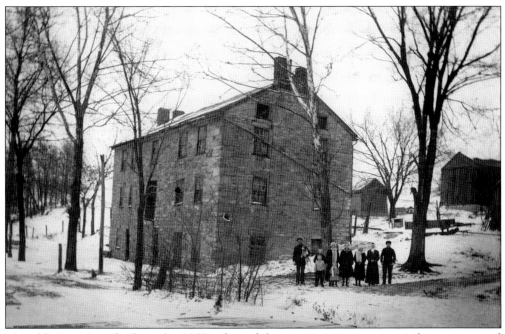

Musick's Ferry Inn, built in the 1850s, thrived for many years as a center of commerce and entertainment. Farmers stopped there for a night's rest, and folks from both sides of the Missouri River came to participate in the gaieties at the tavern or the showboats. (Photograph by George Warren; Missouri Historical Society, St. Louis.)

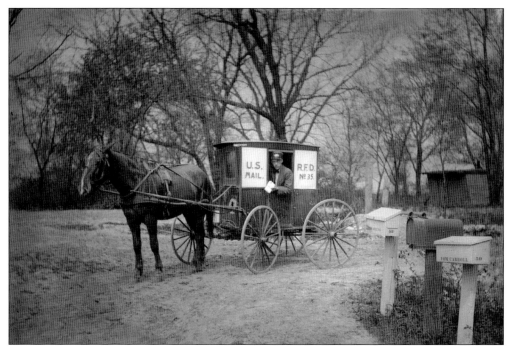

Above, mail is delivered to the Heins and Carroll houses on New Halls Ferry and Douglas Roads, site of Musick's Ferry. Musick's Ferry was named for Reuben Musick, who bought the land and ferry in 1848. Ferry operation had been started around 1800 by Sarah James on her land grant on the west side of Old Jamestown. Musick also operated a sawmill, which prepared boards for Musick Plank Road. In the below photograph, a steamboat pushes a barge up the Missouri River at Musick's Ferry. Steamboats not only carried passengers but also served as workboats carrying equipment and pushing barges and showboats on the river. With sandbars, snags, fires, and explosions, many steamboats did not last long—they had average lifespans of between 5 and 10 years. (Both photographs by George Warren; Missouri Historical Society, St. Louis.)

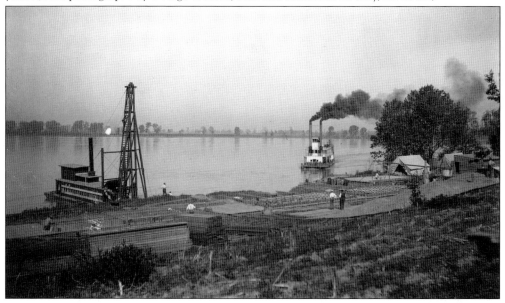

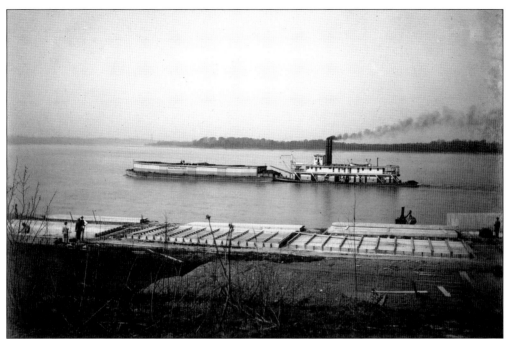

Above, workboats are used to build a dike rig on the Missouri River at Musick's Ferry. In addition to his work for the US Army Corps of Engineers, George Warren leased his land for the construction of river dikes along the shore. The dikes would have protected his family's property, which was losing land to the river. Below, the steamer *Goldenrod* is one of the showboats that spent summer months at Musick's Ferry. Patrons from all over the area came for dinner at the inn and a showboat performance. Many rented a room and stayed for additional shows, which changed every night. It is possible that these showboats also served as speakeasies during Prohibition. (Both photographs by George Warren; Missouri Historical Society, St. Louis.)

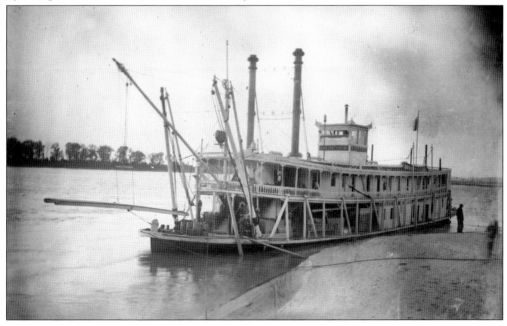

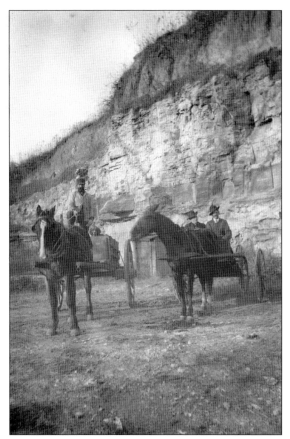

In the image at left, photographer George Warren's father, Jean Baptiste (John B.) Warren, visits the quarry at Musick's Ferry. John B. Warren was born in France in 1847. He emigrated to the United States with his mother and served in the Civil War. After his 1869 marriage to Mary J. Egan, he rented land at Musick's Ferry. He then purchased 42 acres and eventually owned 142 acres and operated a "fine stone" quarry on his property. In the below photograph, men are working at the Warren quarry, which George Warren had continued operating after his father's death. George's photographs for the US Army Corps of Engineers were taken between 1907 and 1918. (Both photographs by George Warren; Missouri Historical Society, St. Louis.)

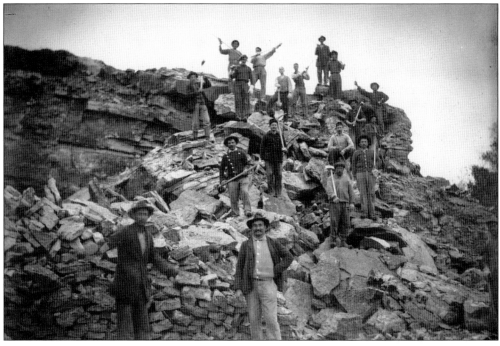

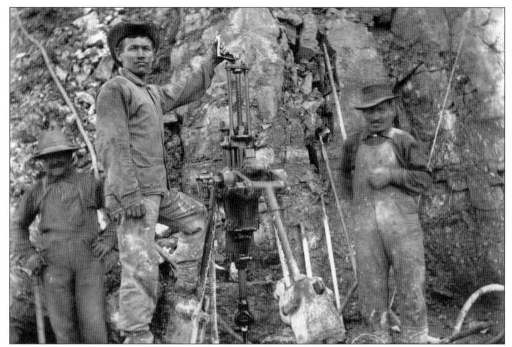

To obtain and break up the stone at the Musick's Ferry quarry required many workers using pickaxes and other hand tools, as well as a mechanical rock drill. They then delivered the rock to customers using horse-drawn wagons. At some point, Musick's Ferry Inn was no longer used for visitors but became living quarters for quarry workmen. The building was then vacant for many years, and eventually, much of it was beyond repair. It was torn down in June 1938. The empty quarry was later owned by John Luecke, who used it for his hauling service. It has a footprint of about 67 acres. (Both photographs by George Warren; Missouri Historical Society, St. Louis.)

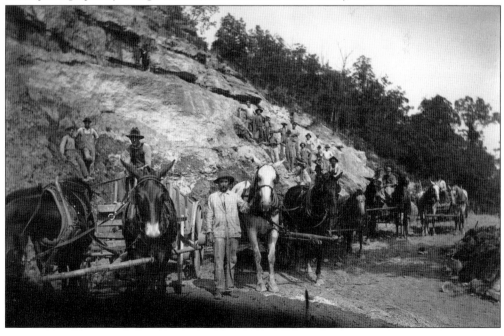

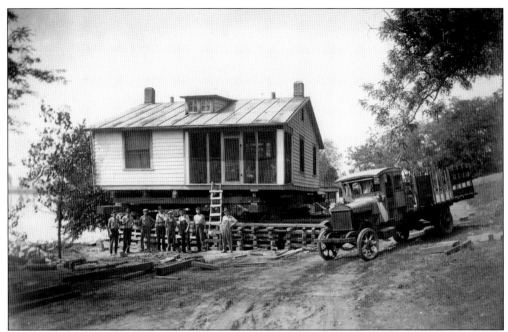

Grandma Warren and children are sitting on the porch of the Warren family house after it was successfully moved up, away from the river, which had changed course over the years. The *St. Louis County Watchman* newspaper reported in 1883 that within the previous 12 years, St. Louis County had lost thousands of acres of its best land to the ever-changing channels of the Missouri River. Farms that were previously the pride of their owners were now the main channel of the Missouri. John B. Warren lost over 30 acres of his land. Just a short distance east, John Thompson lost 70 acres. (Both photographs by George Warren; Missouri Historical Society, St. Louis.)

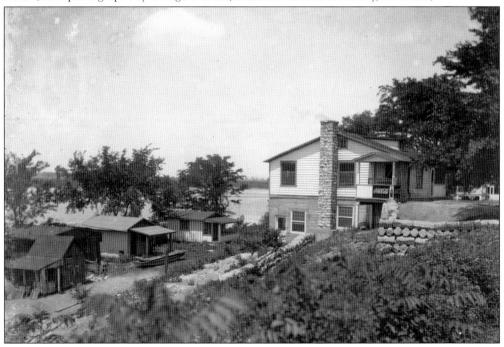

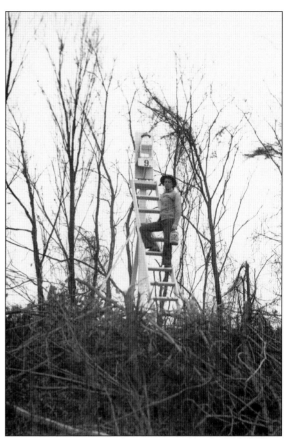

George Adrian Warren's family came to Florissant from Nancy, France. Their original family name was St. Vrain, which was later changed to Warren. He was from a family of quarry-owners, farmers, a piano teacher, land surveyors, a town crier, and mapmakers. George was a professional photographer, farmer, wild-craft winemaker, and constable. He was a lamplighter for river navigation, and his home also served as a landline house for the riverboats. Here, he is filling lighthouse No. 9 with fuel at Musick's Ferry (right), and his newly built barn is being put to use (below). (Both photographs by George Warren; Missouri Historical Society, St. Louis.)

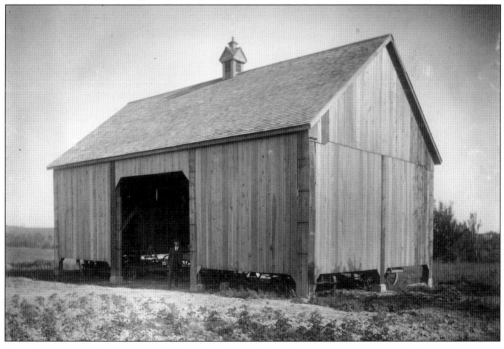

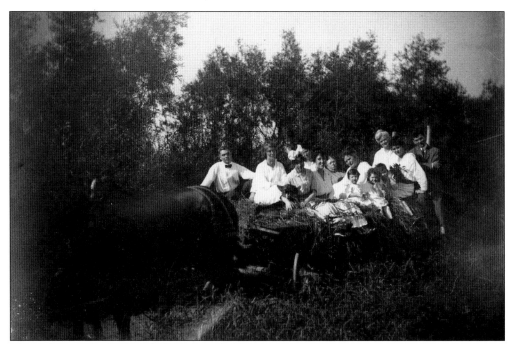

These photographs likely include some of the Warren family as well as other residents of the Musick's Ferry area. Adults and children are enjoying a hayride, and children are utilizing the swing. Here is more information about how the Warren family came to Musick's Ferry—Jean Baptiste Warren was born in France on July 4, 1847, a son of Michael J. and Mary B. (Collett) Warren. His father died in France, and his mother moved to the United States with her only child in 1854 to join her Collett relatives who had been in Florissant since the early 1700s. (Both photographs by George Warren; Missouri Historical Society, St. Louis.)

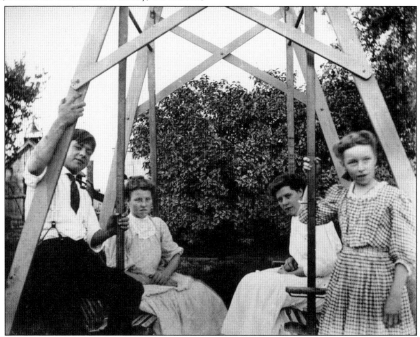

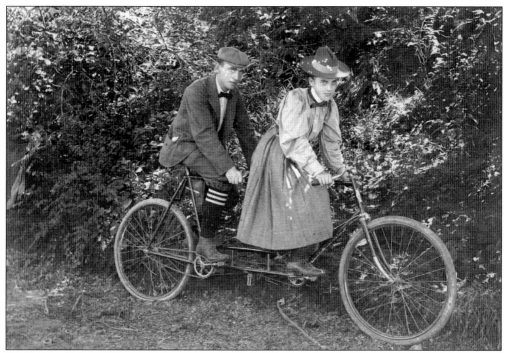

A couple rides a tandem bike at Musick's Ferry. A *St. Louis Post-Dispatch* article provides a glimpse of the area in 1919: "There is now a stand at Musick's Ferry where a light lunch may be purchased. Motorists who want to bring their lunch in a basket will find numerous points along the river that are ideal." (Missouri Historical Society, St. Louis.)

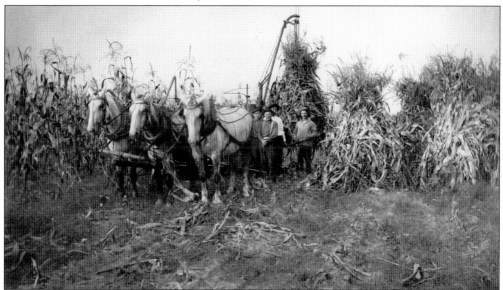

Near Musick's Ferry, horses make corn stacks with Mr. Lindemann, father-in-law of George Warren's daughter Betty Jane Warren Lindemann. Betty (1922–2015) was born at the Warren family home at Musick's Ferry and attended old Brown School. In 1922, the Betty Jane Creek that spills into the Missouri River was named for her. (Photograph by George Warren; Missouri Historical Society, St. Louis.)

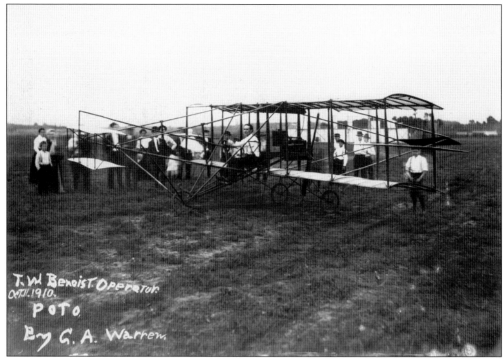

Above is a George Warren photograph of T.W. Benoist taken at Kinloch Field in St. Louis. In 1907, Benoist had helped found the Aeronautic Supply Company (Aerosco), the world's first aircraft parts distributor. In the c. 1910 photograph below, workmen are paving New Halls Ferry Road (St. Louis County Road No. 1), which was surveyed in 1815 from St. Louis to the Missouri River. The road leading from Portage des Sioux on the Mississippi River via Musick's Ferry on the Missouri River to St. Louis was laid out by federal soldiers for travel to their headquarters. In 1857, New Halls Ferry Road was listed on maps as Musick Ferry Plank Road. (Both photographs by George Warren; Missouri Historical Society, St. Louis.)

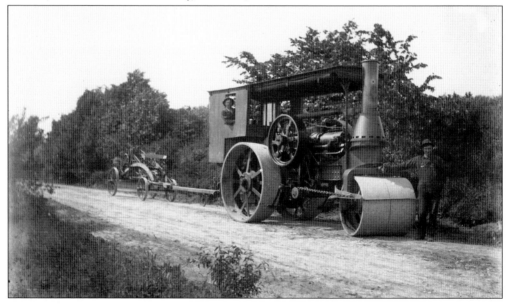

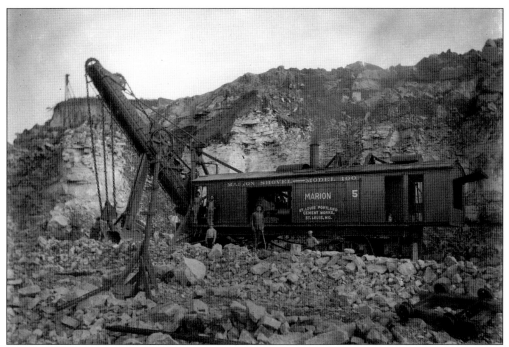

On the far eastern side of Old Jamestown is another quarry where Old Jamestown connects with St. Charles County and Illinois (Alton) via the pictured Burlington Northern railroad bridge as well as Missouri Route 367/US Highway 67 across the Missouri and Mississippi Rivers. Here, workmen are using a Marion Model 100 steam shovel. The quarry was operated by St. Louis Portland Cement Company to provide rock for its cement plant on Riverview Boulevard in St. Louis. This cement plant shut down in 1981, and Portland no longer took rock from its quarry. After several land transfers, the quarry was separated into two tracts; the east tract was owned by Central Stone, and the west tract was owned by Bellefontaine Quarry. (Both photographs by George Warren; Missouri Historical Society, St. Louis.)

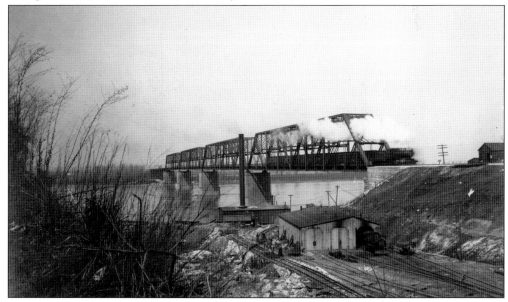

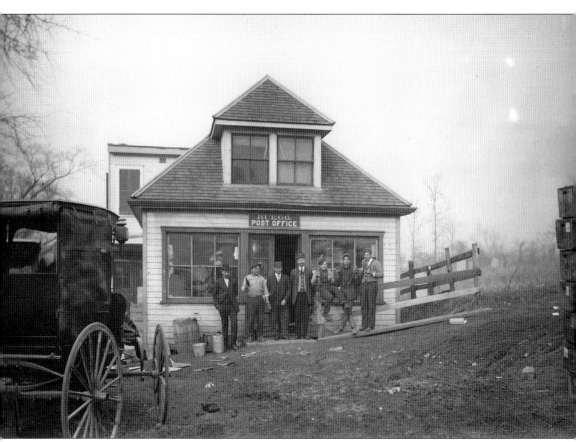

In 1903, John H.C. Ruegg and a partner established a store at the site of the Portland Cement Company's quarry. Ruegg became postmaster of the new town that became a thriving settlement with at least 19 houses for Portland workers and their families. Ruegg had been elected justice of the peace in 1898 and had a reputation as a man who enforced the law regardless of position or influence. He rid the area of many undesirable characters, including three horse thieves in one year. He paid careful attention to the enforcement of the speed law and never hesitated to arrest and fine any man whom he found running an automobile at an excessive rate of speed. In 1910, he was appointed census taker, and he was also a stockholder in the Baden Bank. (Photograph by George Warren; Missouri Historical Society, St. Louis.)

Four

Hardworking Farmers

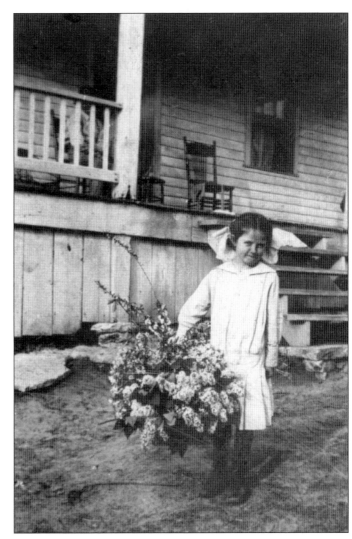

In the 1840s, families boarded ships in Bremen, Germany, and took the two-month trip to New Orleans, then took steamboats for the two-week trip up the Mississippi. They were just some of the hardworking farmers who came to Old Jamestown. Eleanor Hughes, pictured here about 1910, is shown in front of the Hughes family home on Accommodation Road (now Old Jamestown Road). (Historic Florissant, Inc.)

These are early 1880s portraits of John Charles and Louisa Uphoff Hughes who were first-generation Americans of English/Irish and German descent. Louisa's parents, Friedrich (Fred) and Karoline Willhelmeine Niemeier Uphoff, lived on Vaile Avenue. Her sisters, Carrie Uphoff Lampe and Sophia Uphoff Vehlewald, also lived near Old Jamestown and Vaile. From the late 1800s, the Hughes family lived on and farmed land that was part of the current Sioux Passage and Briscoe Parks on Old Jamestown Road. John and Louisa had nine children who reached adulthood. (Both, Michael Brandon.)

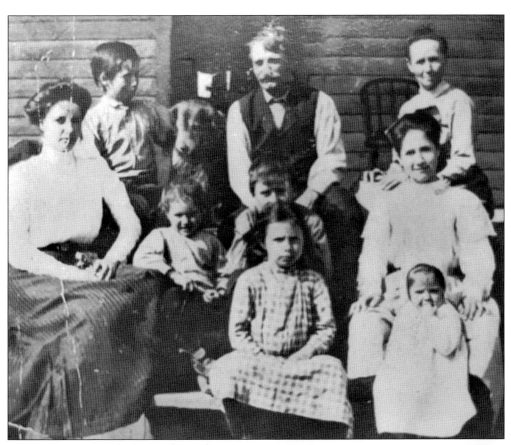

The above photograph shows John and Louisa Hughes with seven of their nine children who lived to adulthood. Pictured are, from left to right, (first row) Clara and Eleanor (Nellie); (second row) Sophia, Oliver (Ollie), Fred (Hobby), and Anna; (third row) John (Jack), John, and Louisa. The two older daughters, Mary and Dora, are not in this photograph. Their oldest daughter, Mary, is shown in the image at right. Two of John and Louisa's daughters married Patterson brothers. Eleanor (Nellie) married Gilbert Patterson and later lived on Carrico Road. Clara married John Patterson; they lived in Ferguson but also had a lot in Castlereagh Estates. (Both, Michael Brandon.)

Two of John and Louisa Hughes's children are pictured here. The photograph at left shows Oliver Hughes with his 1926 Chevrolet. Below is second daughter Dora. Oliver and his wife, Marguerite Holt, and their three sons lived in Ferguson. He worked for the US Postal Service. Between 1930 and 1950, the Hughes land was owned by Louisa Hughes, who handed it down to all the children. The family continued using the farm, but the children had all moved away from it. (Left, Historic Florissant, Inc.; below, Michael Brandon.)

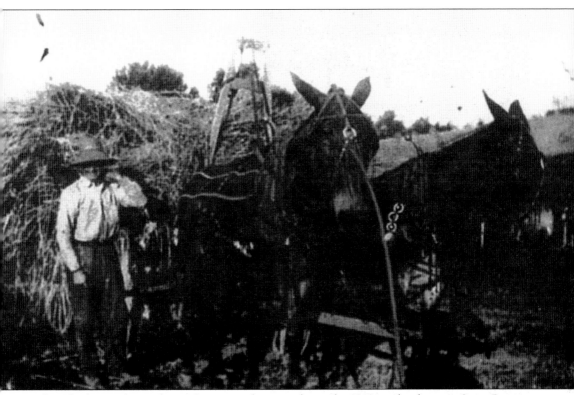

John Charles Hughes is shown farming with two mules in the 1910s on land now in Sioux Passage Park. Mules provided the only assistance (other than human labor) required to accomplish the work of the farmers. The Pattersons also used the land for some farming because they were related to the Hughes daughters. It is very likely that they continued collecting honey from the bees and making molasses and other baked goods. They were all known for their home cooking and use of farm-fresh foods. The family also has a history of making dandelion wine. John, Sophia, and Dora later moved west to homestead in Hesperus, Colorado. John and his wife, Maude, later lived in Yucaipa, California. They came to visit their St. Louis family in a silver trailer. (Michael Brandon.)

John D. Briscoe Park has 33 acres adjacent to the entrance to Sioux Passage Park. John D. Briscoe, born in Sullivan, Missouri, married Mary Hughes, who was a granddaughter of John and Louisa Hughes, who had owned the property from the late 19th century. In 1951, John D. and Mary Briscoe bought the property from the nine children of John and Louisa. Some of the Hughes farm buildings were still standing in 1940, when these photographs were taken—they show the well and shed and may have dated from the Hughes era or earlier. Around 2016, a large communications tower was erected on Briscoe Park land, and it is used to facilitate emergency communications in St. Louis and surrounding counties. (Both, St. Louis County Parks.)

Pictured are two more of the buildings on the Hughes/Briscoe property. John and Mary Hughes Briscoe farmed their property. John also had a private business fashioning handmade prosthetic limbs. John and Mary had no children, and after Mary's death in 1998, John donated the property to St. Louis County. In return, the county agreed to name the tract John D. Briscoe County Park and to lease it back to him for the duration of his life. John died in 2002, and the property was turned over to the county. John Briscoe had a sister, Sarah, who married a Carrico. Sarah was a longtime first- and second-grade teacher at the old Cold Water School. (Both, St. Louis County Parks.)

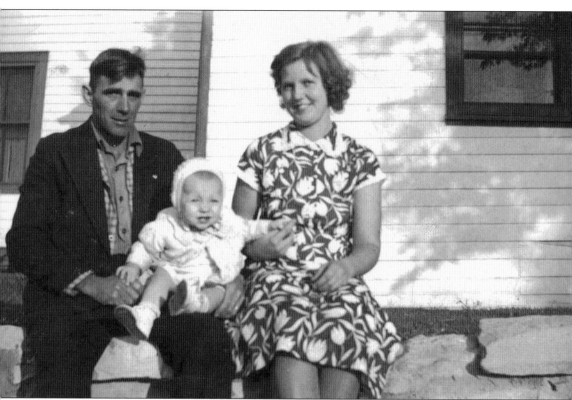

Earl Lange and Wilma Witte were married in 1934 and had three children: Mary, Susan, and Melvin. As newlyweds, the Langes moved to a farm on Vaile Avenue that is now the Talisman subdivision. This photograph shows them in the rear of their Vaile home with their first daughter, Mary. The family also lived on other properties in Old Jamestown. Earl's grandmother, Sophie Schnatzmeyer, married George Rau, who owned property at the northeast corner of Old Jamestown Road and Highway 67. Earl's parents, Ed and Rosie Lange, lived near Sophie. Earl and Wilma's daughter Mary married Gene Stellhorn and lived on Douglas Road. Earl and Wilma's daughter Susan married Ken Meyer, whose parents owned and operated a Standard service station for 27 years on the southeast corner of Highway 67 and Old Halls Ferry Road. Earl and Wilma's son Mel and his wife, Connie, raised their family in a house next to Mill Creek on Old Jamestown Road on acreage that had been part of the Langes' original farm home on Vaile. (Mary Lange Stellhorn.)

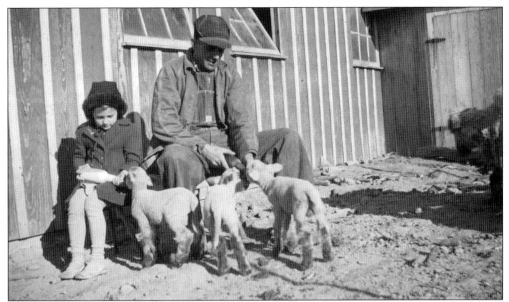

Earl and Wilma Lange rented and farmed the 70-acre Vaile Avenue property. The above photograph shows Earl and his daughter Mary feeding baby lambs at their Vaile Avenue farm in the spring of 1942. The below image shows the Lange family on the front porch of their Vaile Avenue home in the spring of 1943. From left to right are (first row) Mary and Earl Lange; (second row) Wilma Witte Lange, Adele Witte (holding Susan Lange), Elvira Heislen, and Bill Witte. (Both, Mary Lange Stellhorn.)

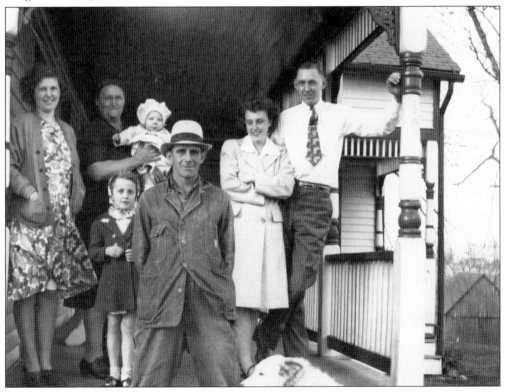

Pictured above is the Lange farm on Vaile Avenue in the early 1940s. Not easily seen are the orchard on the hillside, corn or wheat shocks on the hilltop, the chicken/brooder house, and the garage with a walk-out lower level (both buildings were constructed by Earl Lange). The below photograph shows Earl and his daughter Mary bringing in a load of harvested pumpkins on the Lange Vaile Avenue farm in the fall of 1945. The Langes raised hay, corn, and wheat crops and had orchards, chickens, and dairy cows. Several of the farm buildings are still standing at 4444 Vaile Avenue. (Both, Mary Lange Stellhorn.)

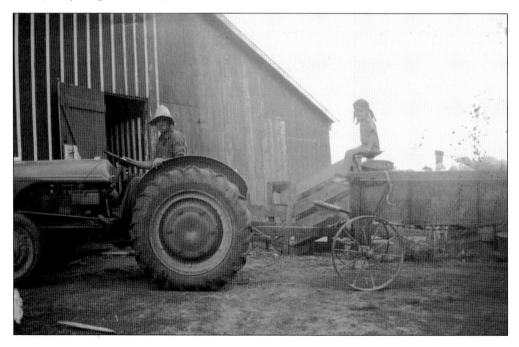

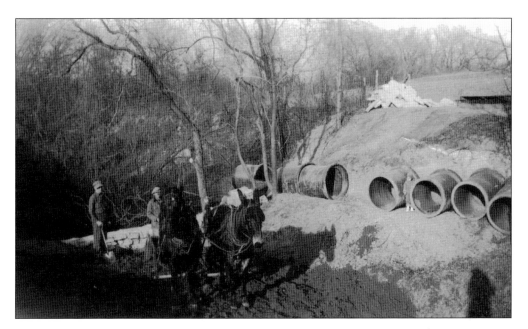

The Langes had to fill in many ditches to make the Vaile Avenue land useful for farming. Above, Earl Lange and his brother-in-law Herman Witte are using farm mules to fill in eroded land near Mill Creek on Vaile Avenue. Earl's daughter Mary is standing between the concrete pipes. The below photograph shows the Wittes and Langes dressed for Easter in 1946 in front of the large farmhouse on Vaile Avenue. From left to right are (first row) Mary and Susan Lange; (second row) Ida Witte Schaeffer, Adele Witte, Wilma Witte Lange, and Norma Witte. (Both, Mary Lange Stellhorn.)

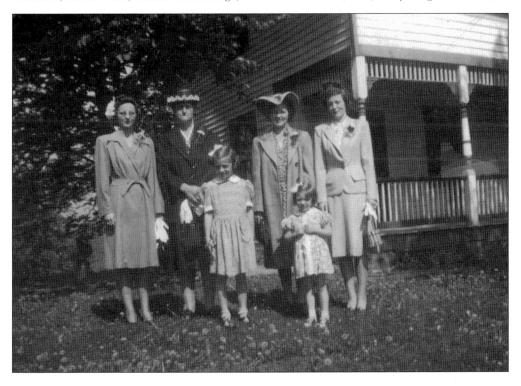

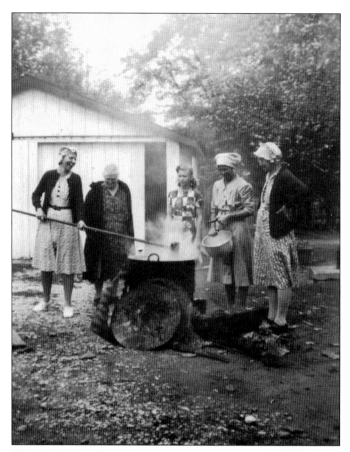

Earl and Wilma Lange also rented and farmed land owned by the Lemkemann family that is now part of Sioux Passage Park on Old Jamestown Road. When it was threshing time, aunts and uncles would show up to help, as they did for apple-butter cooking and beef and hog butchering. At left, from left to right, Alverta Giesendorfer (teacher at Vossenkemper School), Anna Bade, Dorothy Eggert, Rosa Lange, and Louise Merkt are cooking apple butter at the Ed and Rosa Lange farm at 15000 Old Jamestown Road in the mid-1940s. In the below photograph, Wilma Lange and her mother-in-law Rosa Lange are picking raspberries at the Ed and Rosa Lange farm in July 1954. (Both, Mary Lange Stellhorn.)

In December 1946, the Lange family bought farm property on Sinks Road and moved there. Because their home was now in the Vossenkemper School boundaries, the children had to change from attending the one-room Cold Water School, with outhouses and a common drinking dipper, to attending the bigger two-room Vossenkemper School, which had indoor plumbing and individual drinking cups. The photograph at right shows Earl Lange with his farm team. Below, the team is pulling a wagon filled with farm produce at the Sinks Road farm about 1950. (Both, Mary Lange Stellhorn.)

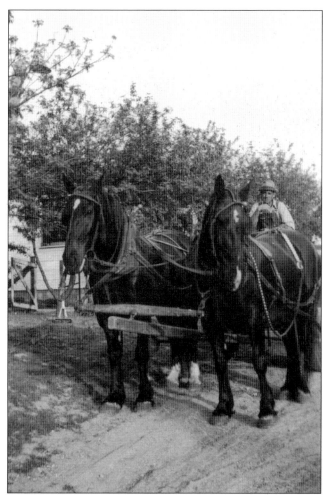

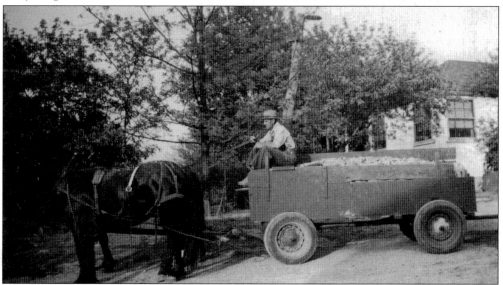

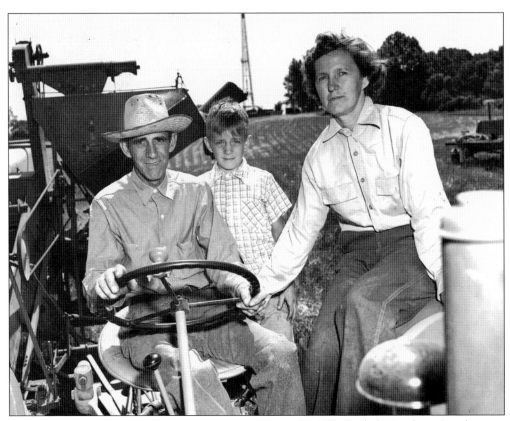

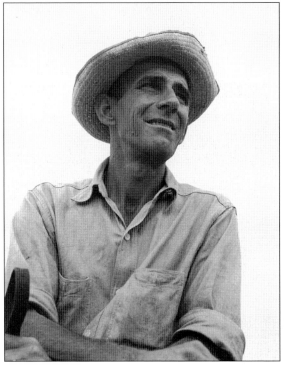

In 1953, Laclede Gas (now Spire) was interested in using the Sinks Road land for its underground gas storage facility. As Laclede was drilling to determine the feasibility of the underground facility, they struck oil. In the above photograph, Earl, Melvin, and Wilma Lange are combining their oat crop with the Laclede Gas exploration rig in the background on the Sinks Road farm in July 1953. The image at left shows Earl Lange surveying his Sinks Road farm in July 1953. After Earl's death from cancer complications in 1953, Laclede Gas bought the 100-acre farm from his wife, Wilma. (Both, Mary Lange Stellhorn.)

In the picture at right, the Lange family stands in front of the Laclede Gas exploration rig in 1953. From left to right are Susan, Mary, Melvin, Earl, and Wilma. In 1957, Mary married Gene Stellhorn (pictured below), who grew up near Old Halls Ferry and Highway 66 (now Dunn Road). When Gene's family started farming their rented land, there were lots of ditches. After Gene's dad, Art, leveled the ditches with his tractor and loader, Art began repairing lawn mowers. Art had access to lathes at his job and used them to build clutches. He then attached a clutch and a gasoline-powered washing-machine motor to a reel-type lawn mower, converting it into a power mower. Art's neighbors soon also wanted a power mower. In 1951, Toro asked Art to be a dealer, and Art's Lawn Mower Shop was born. (Both, Mary Lange Stellhorn.)

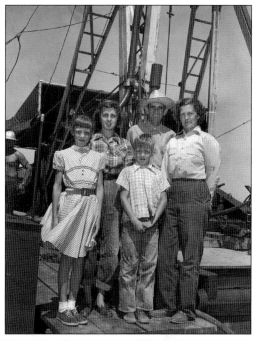

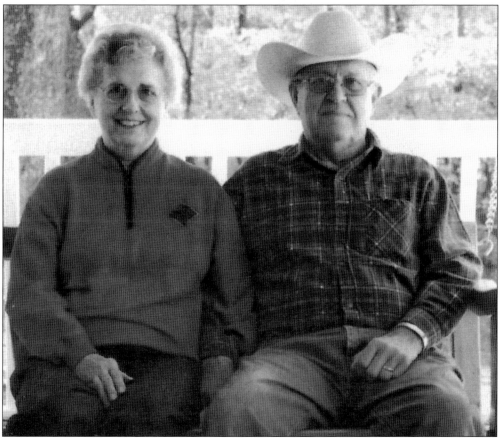

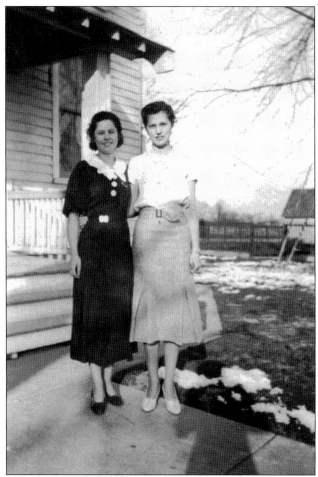

The photograph at left shows Margaret Carrico and Wilma Lange in front of the Carrico farmhouse, where Margaret hosted a bridal shower for Wilma in the spring of 1934. The house, which was on Wehmer Estates Drive, has since been torn down. Below, Margaret Carrico is sitting in Bill Bardon's Chevrolet in the early 1930s. Five members of the Carrico family settled in the Florissant area in the late 1700s and early 1800s—brothers Vincent, Walter, and Dennis and sisters Theresa and Elizabeth, all of whom were born in Charles County, Maryland. Though the Carricos' land grants were not within the Old Jamestown boundaries, Vincent (1764-1816) had a grant just east of Old Jamestown and purchased John Brown's land, and other Carricos purchased land from members of the Hodges family. (Both, Mary Lange Stellhorn.)

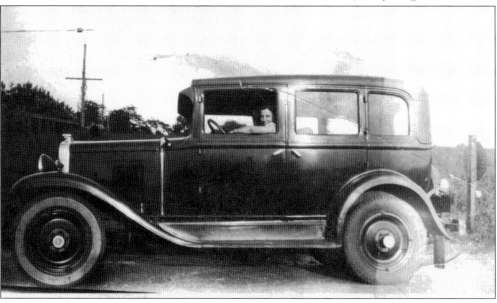

Glen Niehaus, who lives on Sinks Road, was the last of a long line of Niehaus carpenters. Glen's great-grandfather Herman Niehaus (1884–1967) was one of the 11 children of Herman Henry Harmon Niehaus (1852–1908), who came to St. Louis County from Germany in 1867, and Marie "Mary" Gerling Niehaus (1852–1920), who arrived from Germany in 1856. Herman married Caroline Kamp (1885–1973) in 1907, and they had three sons: Harvey Heinrich Herman, Elmer August, and Harold Edward. Herman built many homes in Old Jamestown, and members of his family were also carpenters. The young women in these photographs are attending a Walther League Picnic at the Niehaus Farm on Old Jamestown Road. (Both, Mary Lange Stellhorn.)

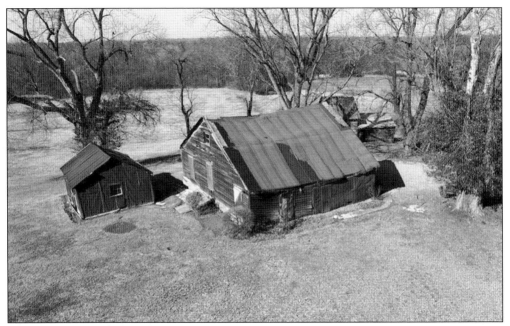

The Buenger Farmstead on 17790 Old Jamestown Road is one of the last farmsteads in the area that still contains a house, a barn, and other farm buildings, all of which are now vacant. The current farmstead is on four acres. Forty-five acres were sold to Behlmann Properties in 1987 and now comprise Parc Argonne Estates. It is believed that this house was built in the early 1800s. There are two main original interior rooms of log construction, with the entire house covered with aged weather boards. The noticeable roof sag results from roof rafters made from tree saplings cut from the woods. Younger members of the Buenger family now live across the street in homes built in 1990. Earlier Buenger family members owned 280 acres nearby, which were sold in 1978 and became part of the Jamestown Farms subdivision. (Above, photograph by Chandan Mahanta; below, photograph by Beverly Girardier.)

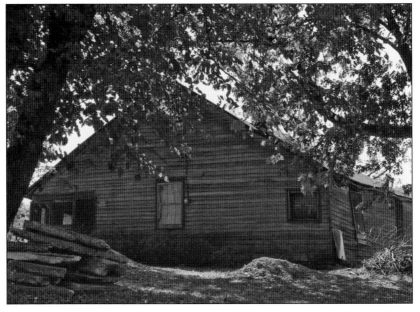

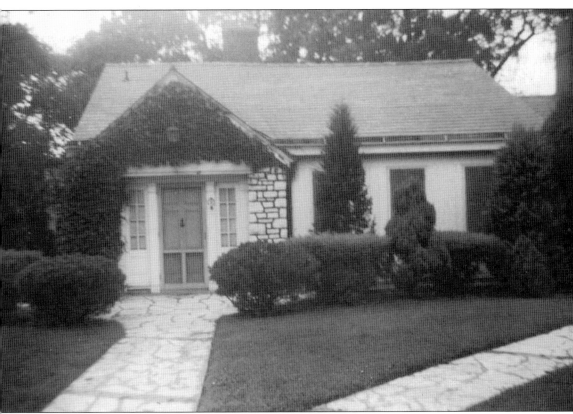

This home began as the summer home of Louis Nolte, who was the comptroller for the City of St. Louis. He built the lodge as a hunting and fishing retreat using materials and employees from the city and funds from the WPA (Works Progress Administration), which was designed to put people back to work after the Great Depression. It was built at the same time—and with the same stone—as the Fort Bellefontaine bathhouses and staircase. The property was like a park, and the public was allowed to have picnics on the lakeside. When it was first built, the house had no bedrooms but did have two Murphy beds in a closet on the sunporch. It was later renovated to include bedrooms and is now the home of Susan Wehmer Kagy and her family. (Mary Lange Stellhorn.)

Descendants of Henry Wehmer have long been a major part of the community and continue to live in Old Jamestown. Henry was born in Prussia, Germany, in 1852, and came to the United States when he was 15 years old. In 1876, he married Sophia Marie Louise Buhrmeister, also a native of Prussia and a former schoolmate of his. After his marriage, he rented and farmed land on Douglas Road, which is the site of this home. Henry and Sophia had eight children: Carrie, Edward, Fred, Henry (a stationary engineer), Louis (employed by Norman Shapleigh Hardware Company), Paul, Esther, and Emily. (Above, Virginia Wehmer Borcherding; left, Missouri Historical Society, St. Louis.)

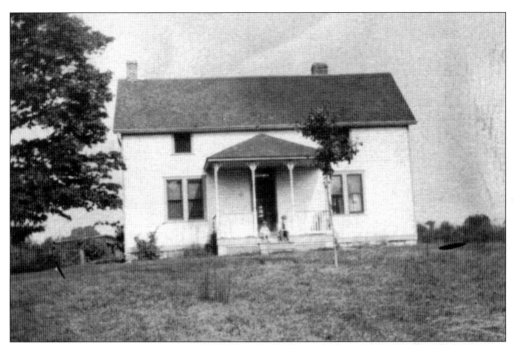

Henry Wehmer's son Louis married Aurelia Thompson. Aurelia's father, James Thompson, was born in Glasgow, Scotland, in 1843. When James Thompson was two years old, he came to the United States with his mother. In 1877, James's wife, Margaret Carrico Thompson, inherited 47 acres on what is now Carrico Road. He later bought another 60 acres. In 1908, he lost 70 acres of his land when the Missouri River's course changed. Thompson's Carrico Road home is pictured above. On the steps are his daughter Aurelia and son Elmer, who were both born in the home. (Above, Virginia Wehmer Borcherding; right, Missouri Historical Society, St. Louis.)

When their children were very young, Louis and Aurelia Wehmer lived in a log cabin. The above photograph is of the later family homestead on Curlee Lane. Back then, Accommodation Road (now Old Jamestown Road) was a dirt thoroughfare. The nearest doctor was in Florissant, so the Wehmers drove their Model T car, hitched to a team of mules, to Salem Baptist Church, holding the reins through the windshield opening. They left the mules at the church and drove on to the doctor's office. Their four sons (pictured below, from left to right) Jim, Bob, Ralph, and Louis obviously enjoyed each other's company. Here, they are sporting cigars—an attempt to have fun with their father, who had promised them all a gold watch and $100 if they did not smoke or drink before age 21. They had all successfully met his challenge. (Both, Susan Wehmer Kagy.)

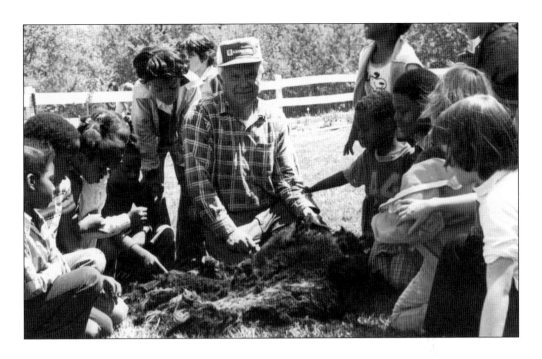

Above, Louis Wehmer's son Ralph is showing students how he sheared sheep at a Ferguson-Florissant School District Little Creek Wildlife Area demonstration. The below photograph is of the thresher purchased by Louis in 1904 at the World's Fair in St. Louis. Many current subdivisions—Shamblin, Fountainbleu, Old Jamestown Estates, Afshari Estates, and Wehmer Estates—are on land once owned by Wehmer family members. Joseph Afshari, a developer in Old Jamestown, built his home in the Afshari subdivision on the same spot as the log cabin where Ralph Wehmer was born in 1916. (Both, Susan Wehmer Kagy.)

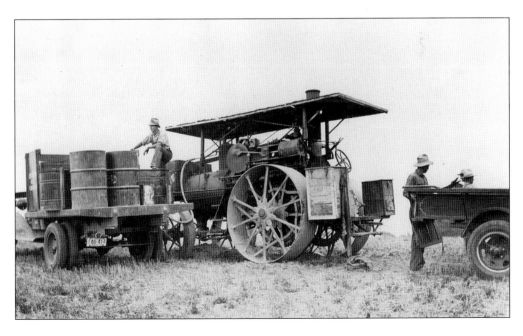

Pictured above are members of the Junior Homemakers, which was a program of the US Department of Agriculture's Cooperative Extension Service. The goal was to teach women in rural parts of the country better methods for getting work done in areas such as gardening, canning, nutrition, and sewing and to encourage them to improve their families' living conditions. Home demonstration agents worked with local clubs to provide teaching services. In the below photograph are members of the Triple C (Coldwater Community Club) 4-H Club. The girls' club was led by Hilda Albers Kuhn, who grew up on the Charles Albers family farm on New Halls Ferry Road. The boys' club was led by the younger Louis Wehmer. The below photograph includes the four sons of Louis and Aurelia Wehmer: Louis, Ralph, Jim, and Bob. (Above, Susan Wehmer Kagy; below, Linda Wehmer Wolfe.)

Five

NOTABLES ALONG THE RIVER

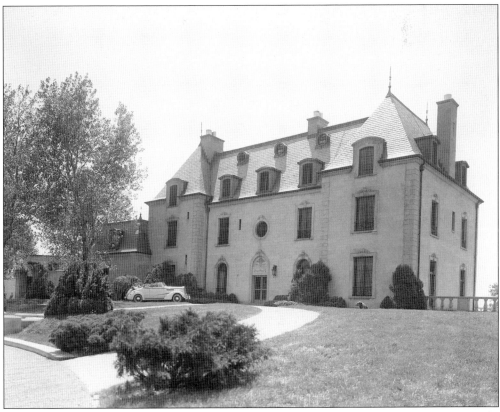

Like the Native Americans and early European arrivals, the wealthy recognized the value of the Missouri River bluffs and began to arrive as roads and cars made travel easier. In 1919, Joseph Desloge Sr. bought a large tract of land near New Halls Ferry and Shackelford Roads and built Vouziers, a Louis XVI–style chateau inspired by his service in France during World War I. (Photograph by Charles Trefts; State Historical Society of Missouri)

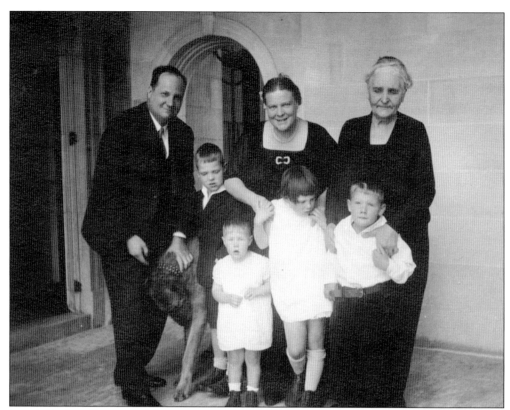

Joseph Desloge Sr. married Anne Kennett Farrar, who is pictured above with her brother, their mother, and Anne's four children. From left to right are (first row) Joseph Desloge Jr., Zoe Desloge, Anne Desloge, Bernard Desloge; (second row) Dearborn David Farrar, Anne Kennett Farrar Desloge, and Elizabeth Keersacker Farrar. Joseph and Anne Desloge and their children lived in the 10-bedroom, four-story mansion. As adults, most of the Desloge children lived nearby. The mansion and its grounds were later sold to the Kroeger family. The Kroegers sold it in the 1990s to McDonnell Douglas (now Boeing) for their Leadership Center, which hosted employees and others from all over the world for classes and meetings. The property was again listed for sale in 2023. (Both, Missouri Historical Society, St. Louis.)

Pictured at right are Joseph Desloge Sr. and his two sons, Joseph Jr. (left) and Bernard (called Barney) (right). Pictured below are Joseph Sr.'s daughters Anne (left) and Zoe (right). Both photographs were taken in 1938. Zoe was an accomplished athlete and horsewoman. Bernard led the family mining business in southeastern Illinois. Anne was an accomplished equestrian and a founding member of the Bridlespur Hunt; she was also the 1946 Veiled Prophet queen. Joseph Jr. volunteered with the American Field Service in World War II and, attached to the British Army, saw action in North Africa and Italy. He later wrote a book about his life, *Passport to Manhood*, which was published in 1995. (Both photographs by Charles Trefts; State Historical Society of Missouri.)

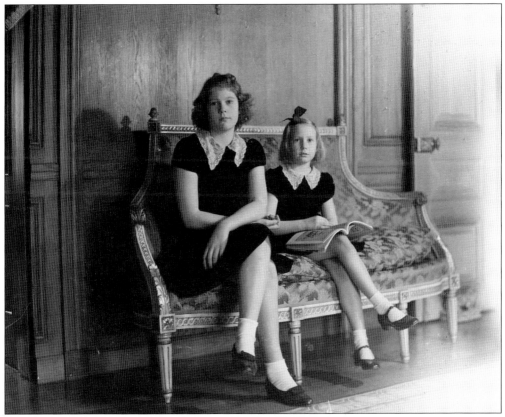

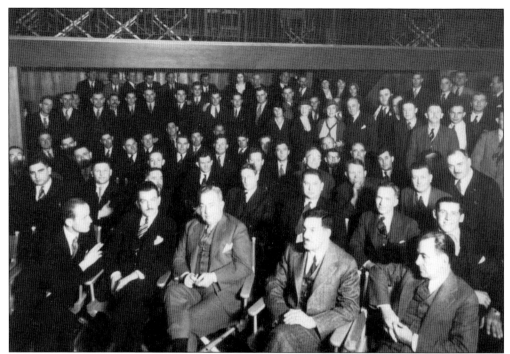

Members of the Desloge family were active in their community and hosted charitable and other gatherings. A 4,000-square-foot ballroom built into the hillside is connected to a parking area through an underground tunnel. The above photograph shows a 1930 meeting of the Florissant Valley Roadside Improvement Society. The society's purpose was to encourage people to take pride in the appearance of their property. Pictured below is a 1959 Garden Club of America zone meeting. Joseph Desloge was a strong supporter of conservation, and in 1955, he donated to the state of Missouri 2,400 acres in Reynolds County, which composes the bulk of Johnson's Shut-Ins State Park. The family also sold Pelican Island at 25 percent of its value to St. Louis County, which later turned it over to the Missouri Department of Conservation. (Above, Historic Florissant, Inc.; below, Missouri Historical Society, St. Louis.)

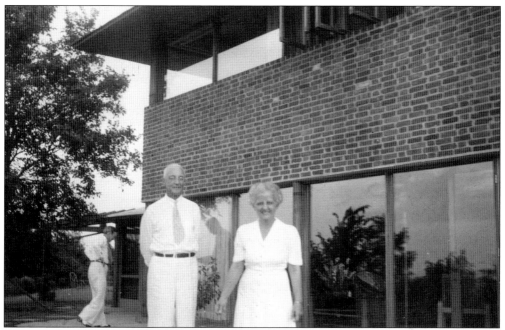

The Missouri bluffs also attracted distinguished physicians, including Evarts A. Graham, MD, FACS (1883–1957), and his family, who lived on Jamestown Acres in the 1940s and 1950s. Dr. Graham was a professor, physician, and surgeon who served as chairman of the department of surgery at Washington University School of Medicine from 1919 to 1951. Above, Dr. Graham and his wife, Helen Tredway Graham, are shown in front of their home around 1955. Featured below is a more complete picture of the home designed by Harris Armstrong, a well-known St. Louis architect. (Above, Bernard Becker Medical Library Archives, Washington University School of Medicine; below, St. Louis County Parks Department.)

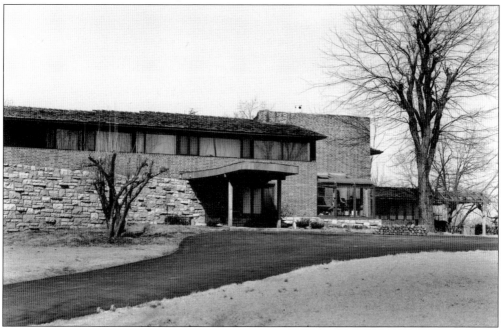

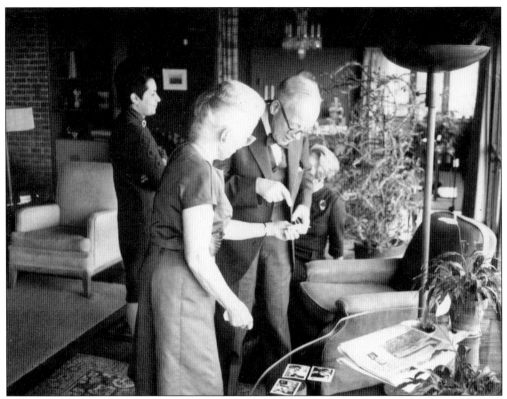

These photographs show a gathering at the Graham home, where Helen Tredway Graham loved to entertain. The above image shows J. Harold Burn and Helen examining photographs in the Graham home. Anne Marie Kuhlmann and Helen B. Burch are in the background of the photograph, which is dated March 3, 1968. Below is another picture of Helen Tredway Graham and Burn. Evarts, the son of Helen Tredway and Evarts A. Graham, was managing editor of the *St. Louis Post-Dispatch* from 1968 to 1979. (Both, Bernard Becker Medical Library Archives, Washington University School of Medicine.)

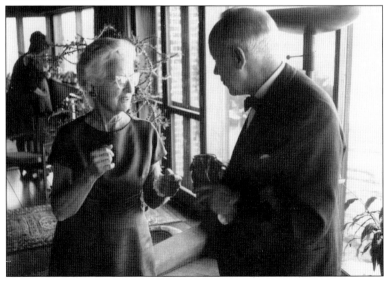

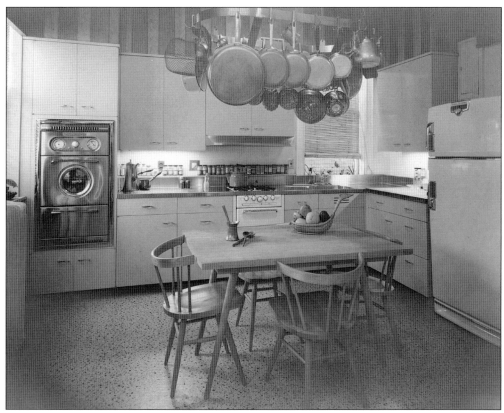

These photographs show the kitchen and living room of Evarts and Helen Tredway Graham's home. It is ironic that despite his research findings that cigarette smoke caused cancer, he himself smoked and ended up dying of lung cancer. Note the cigarettes on the table in the living room. Dr. Graham and Dr. Ernst Wynder conducted the first large-scale systematic research on the carcinogenic effects of cigarette smoking. Dr. Graham was best known for collaborating on the first successful removal of a lung for the treatment of lung cancer in 1933. He also developed the first procedure for imaging the gallbladder. (Both, Missouri Historical Society, St. Louis.)

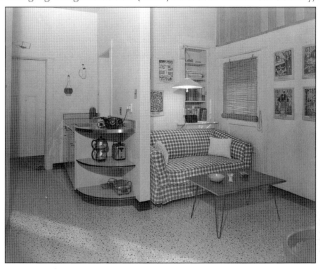

Other Washington University physicians and researchers who had homes along the Missouri River included Vilray P. Blair, MD, who lived on Portage Road, and Alexis Hartmann, MD, and his son Alexis Hartmann Jr., MD, who had a summer home on Jamestown Acres. Ellis Fischel, MD, had a guest home on Portage Road. The photograph at left shows Earl and Wilma Lange in front of Dr. Blair's home. Pictured below is John B.G. Mesker's home near Old Jamestown Road on a 10-acre lot, which he bought from Marion Blossom in 1936. Construction began on the site overlooking the Missouri River in 1939. Architects Study & Farrar designed the home in a French chateau style. (Left, Mary Lange Stellhorn; below, photograph by Chandan Mahanta; Mark and Chris Waier.)

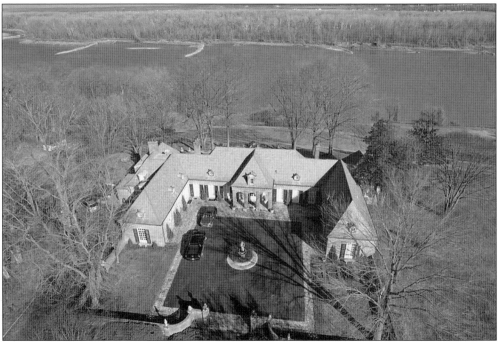

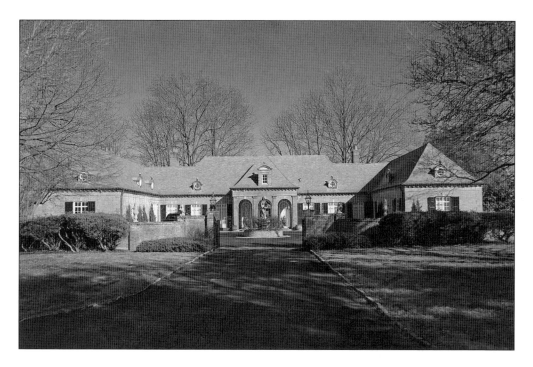

In 2008, brothers Mark and Chris Waier, who grew up on Old Jamestown Road, purchased the John B.G. Mesker home after a period of decline and painstakingly restored the house and grounds to their former glory. The owners' suite had a sunken marble bathtub. For economical use of the space, the storerooms and servants' quarters were on the second floor above the garage wing. Mark says, "The colors we used throughout the house are now accurate to the period of construction—1939." (Both photographs by Chandan Mahanta; Mark and Chris Waier.)

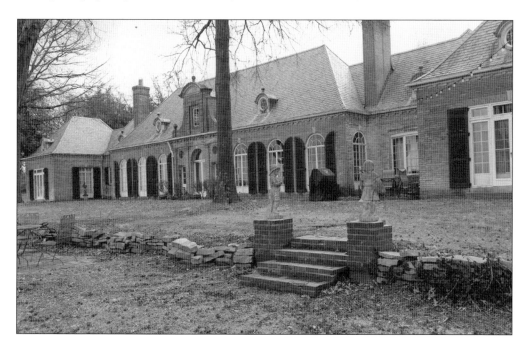

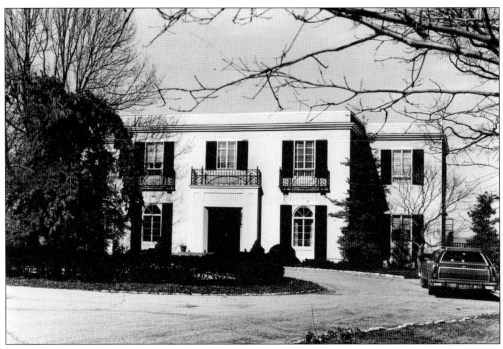

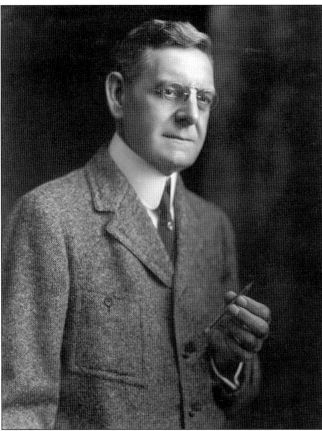

Francis Mesker, brother of John B.G. Mesker, purchased 33.44 acres near Old Jamestown Road in 1933. His home was made of cast iron and built as an experiment by Mesker Brothers Iron Company, which was founded in 1879 by Francis's father, Frank Mesker, and uncle Bernard Theodore Mesker. The firm was known for sheet metal work and later made special windows and doors. Francis graduated from MIT in 1927 and joined the company, later becoming vice president. He retired in 1961, and the company closed in 1966. Francis Mesker's home is pictured above. The photograph at left shows Frank Mesker around 1930. (Above, St. Louis County Parks Department; left, Missouri Historical Society, St. Louis.)

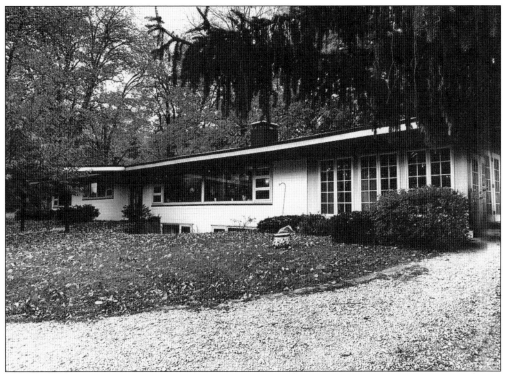

This home on Old Jamestown Road was designed by Harris Armstrong for T. Gaynor and Jane Spore Blake. Gaynor Blake attended Princeton and earned his bachelor's degree in chemistry at Central Methodist College. He also did postgraduate work at Washington University. He worked for Olin Mathieson Chemical Corporation, where his principal work was research, development, and design of explosives and pyrotechnics. This moved to production after he founded his own small firm, Hanley Industries, a manufacturer of defense items. The Blakes were active in the community and participated in the formation of the Old Jamestown Association in 1942. The home is currently owned by Jesse and Courtney Fister, who live there with their children. (Both, Jesse Fister.)

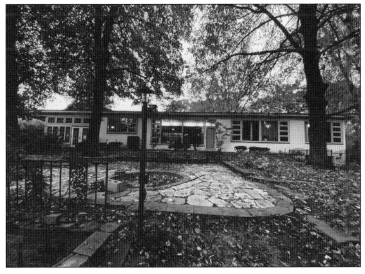

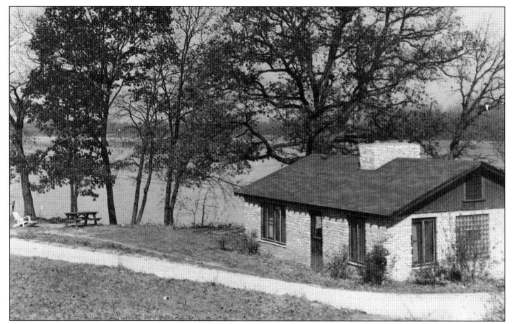

Lyle (1914–2004) and Nadine (1915–2005) McNair, founders of St. Louis Cold Drawn, Inc., built their home on the Missouri River on Old Jamestown Lane in 1955. Their son, Bill, current owner of St. Louis Cold Drawn, built another home there in 1984 and still lives on the property. The McNairs married in 1938 and started Hazelwood Engineering and later opened aluminum plants in Murphysboro and DuQuoin, Illinois. They founded St. Louis Cold Drawn in 1971 as a start-up company making cold-finished steel bars. Operations were held in a small industrial garage with an annual production capacity of 2,000 tons. Now, St. Louis Cold Drawn operates with an annual production capacity of 250,000 tons in two states and in Mexico. Nadine and Lyle were both licensed Missouri professional engineers and aircraft pilots. (Both, Kristen McNair.)

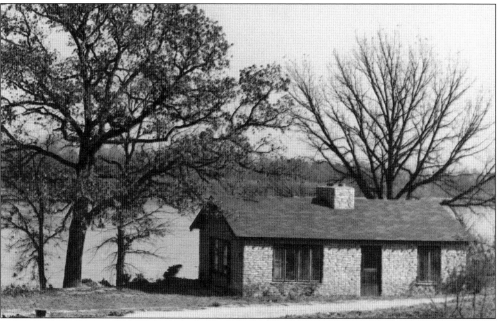

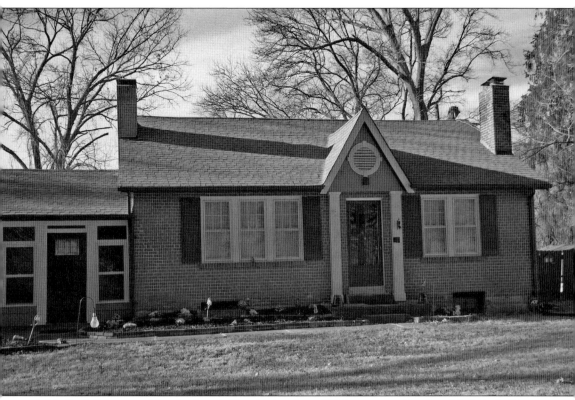

Adela Riek Scharr and her husband, Harold, lived on Old Jamestown Road in Black Jack. Her parents lived on the Old Jamestown side of Coldwater Creek. Scharr's parents' home is pictured above. While teaching at an elementary school in St. Louis in the 1930s, Adela Scharr took streetcars and buses to Lambert Field to take flying lessons. When she married Harold, she had to resign her teaching position with the St. Louis Board of Education. She taught ground school at St. Louis University, flew passengers for joyrides on weekends, kept house, and continued to learn until she finally had her flight instructor's rating. During World War II, Adela delivered military planes for the Women's Airforce Service Pilots (WASP). Adela wrote hundreds of letters to her husband, which became the basis of a two-volume book set called *Sisters in the Sky*. After the war, Adela taught flying at Lambert Field. (Photograph by Chandan Mahanta.)

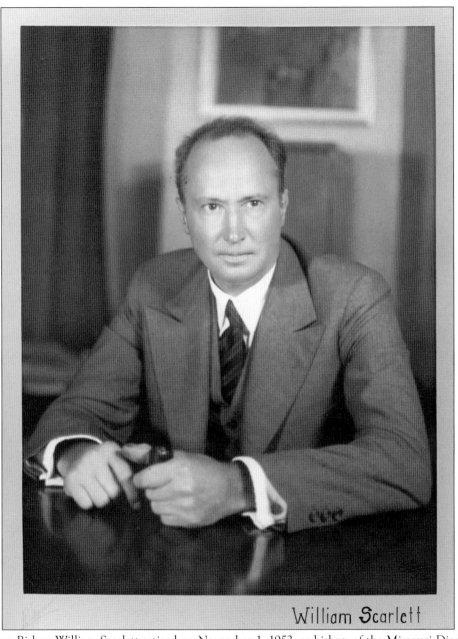

When Bishop William Scarlett retired on November 1, 1952, as bishop of the Missouri Diocese of the Episcopal Church, he continued to live on Jamestown Acres in a house that overlooks the Missouri River. He graduated from Harvard University in 1905 and from the Episcopal Theological Seminary in Cambridge, Massachusetts, in 1909. A friend of Eleanor Roosevelt, Bishop Scarlett served as president of the Urban League for 16 years. He was also chairman of the Joint Commission on Social Reconstruction of the Episcopal Church and chairman of the Department of International Justice and Goodwill of the National Council of Churches. He was a national leader in promoting church unity. In 1952, Scarlett was praised by Associate Justice Felix Frankfurter of the US Supreme Court as "the highest representative of the tradition which binds us together and makes us a nation." (Missouri Historical Society, St. Louis.)

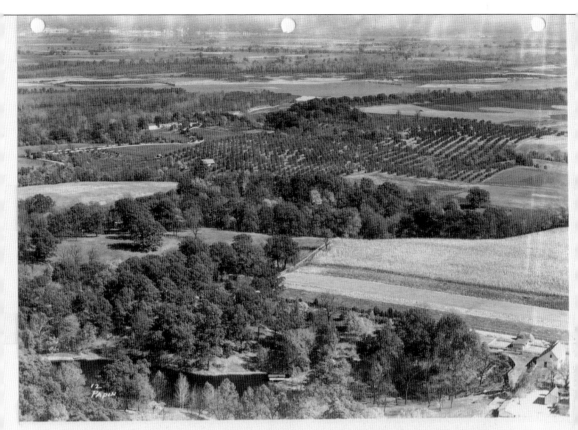

Low altitude aerial view, looking NE in this picture, and looking SW in picture on reverse side of this page, of the Curlee property before subdivision into Castlereagh Estates. These views were obviously taken some years before 1956 as evidenced by condition of the formal garden and flower garden in front of the main house as compared with the neglect of the same area evident in the high altitude photos we had taken in 1956. The buildings in the lower right hand corner are the out buildings of the Weimer farm. The Weimers owned a good deal of the surrounding land prior to 1956.

In the early 1900s, Shelby Curlee, co-owner of Curlee Clothing Company, owned property overlooking the Car of Commerce Chute and the Missouri River, which has since become Castlereagh Subdivision. Curlee had a mansion and a very large orchard. Curlee was born in Corinth, Mississippi, in 1868. In 1900, he cofounded Corinth Woolen Mills, manufacturer of pants and children's clothing. In 1903, the company relocated to St. Louis, and eventually, the company (renamed Curlee Clothing Company) became one of the most successful clothing manufacturers in the country; during the 1940s, Curlee Clothing Company was larger than Levi Strauss. Shelby's brother, Col. Francis Curlee, also co-owned the clothing company. Francis bought the historic Nathan Boone home near Defiance, Missouri, which later became open to the public. Francis and Shelby were great-grandnephews of Daniel Boone, who died in the Defiance home in 1820. (Patty Murray.)

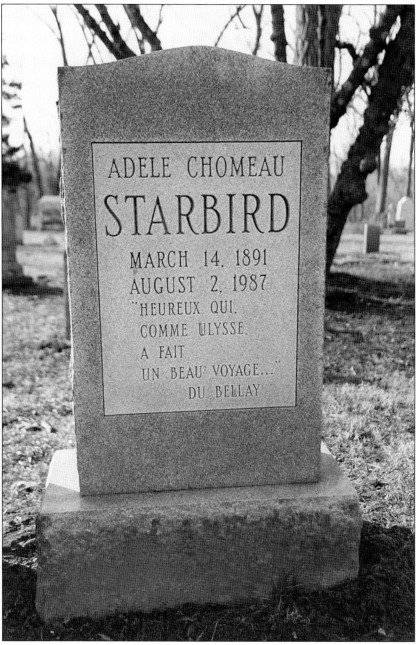

Adele Chomeau Starbird was dean of women at Washington University from 1931 to 1959. From 1946 to 1979, she wrote a popular newspaper column that appeared in the *Star-Times* for the first five years and then in the *St. Louis Post-Dispatch*. Adele's father, Henri Chomeau, founder and president of the St. Louis County Land Title Company, spent part of his youth living in Old Jamestown. His wives, Mary "Mollie" and Virena, who were daughters of Nicholas and Margaret Patterson Douglass, grew up in the Tunstall-Douglass House on Old Halls Ferry Road. Mary died in childbirth. Henri later married Virena, and they had three children, including Adele. In 1912, Adele married Robert Starbird, a Washington University professor. Robert died in 1916. Adele and her parents are buried in Cold Water Cemetery. (Photograph by Chandan Mahanta.)

Six
ORGANIZATIONS AND BUSINESSES

Old Jamestown is part of the Black Jack Fire Protection District, which began in 1929 after a fire destroyed a house on Mehl Avenue. A crew of volunteer firefighters from Florissant Valley responded to a frantic call for assistance but could not save the house. Within days, several community leaders held a meeting and put a plan in motion to start a fire protection district. (Black Jack Fire Protection District.)

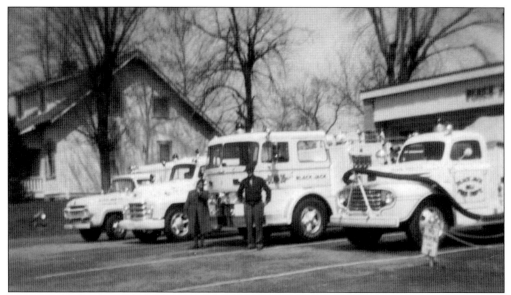

Black Jack Fire Protection District covers 26 square miles in north St. Louis County. The district has three firehouses. The above photograph was taken in 1962 at firehouse No. 1 on Old Halls Ferry Road. Firehouse No. 2 is on Old Jamestown Road near Sioux Passage Park, and No. 3, which also houses the administration building, is on North Highway 67. The below photograph shows fire chief Earl (Bob) Dick, who retired in 1993. Larry Harden is to his far right, and the other firefighters are unidentified. The district has state-of-the-art fire suppression equipment, and firefighters are trained in various types of rescues, including vehicle extrication, high-angle rescue, and water rescue. Some members are on regional and national urban search-and-rescue teams, as well as the St. Louis County Hazardous Materials Response Team. (Both, Black Jack Fire Protection District.)

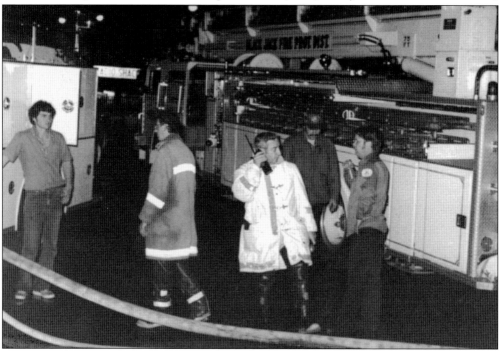

Black Jack Fire Protection District responds to over 5,000 calls per year and provides fire, rescue, and emergency medical services to residents. Of 35 current employees, Black Jack staffs 17 paramedics and 15 EMTs. The fire district contracts with Christian Hospital EMS for transport service, which has units stationed at two of the firehouses. The above image shows Christian Hospital Northeast medic David Tettroff receiving an award from fire chief Robert Coffman, who retired in 2002. In the below photograph, taken more than 20 years ago, is Michael Scott, who was a member of the board of directors and later became a fireman, then a captain. The others are Capt. Michael Beckmann, Capt. Morad Badwan, and battalion chief Michael Brock. The firefighters also serve the community through the Black Jack Firefighters Community Outreach. (Both, Black Jack Fire Protection District.)

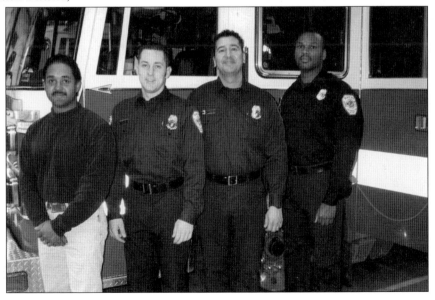

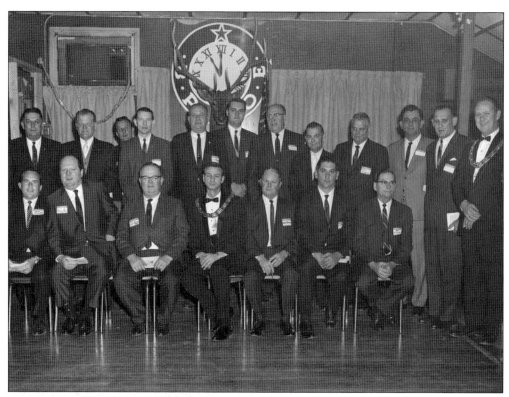

In 1965, the North County Benevolent and Protective Order of Elks Lodge No. 2316 was organized with 165 charter members. The group's first meetings were held at several locations in the Florissant area. In 1983, the Elks began building their fifth meeting facility at the current location in Old Jamestown at 16400 New Halls Ferry Road. The above photograph shows lodge and state officers in 1968. The first Inaugural Ball was held in 1965 at the Lambert Field Officers' Club. Dress was tuxedoes and formalwear. The photograph at left shows former Florissant mayor James Eagan addressing the Elks. (Both, Florissant Elks Lodge No. 2316.)

The above photograph shows the 1984 construction of the New Halls Ferry Elks lodge. A grand opening for the Florissant Elks Lodge No. 2316 was held in March 1986. Pictured below is the burning of the mortgage in 1991. Meat shoots were held in the very early years of the lodge, when the Elks were meeting at the Barn Deli Restaurant on Florissant Road. In 1967, a luau was held at the Barn Deli with 500 people attending. The current Florissant Elks Lodge is used for meetings, social functions, fish fries, and bingo, and the Elks rent the hall out for weddings and other gatherings. (Both, Florissant Elks Lodge No. 2316.)

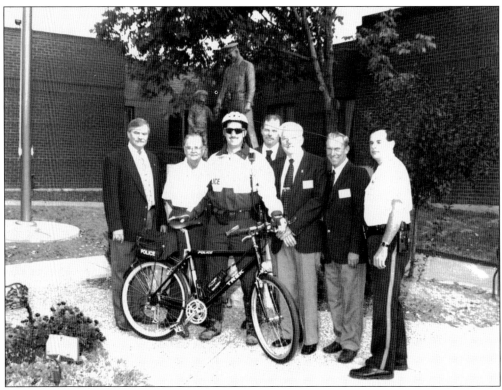

The Ladies' Club was formed the same year as the Elks Lodge—1965. It was declared an Auxiliary of the Florissant Elks in 1995 by the Grand Lodge. Both the lodge and the ladies' club have long been involved in community service and support. Both groups hold weekly bingos at the lodge, and the proceeds are used for nursing scholarships and other charitable and community activities. Several of the Elks visit the St. Louis Veterans Home monthly to host bingo for the residents. The above photograph shows Elks presenting a mountain bicycle to the Florissant Police Department in 1996. The lodge is pictured below in 1997. (Both, Florissant Elks Lodge No. 2316.)

Pallottine Renewal Center sits on 83 acres at 15270 Old Halls Ferry Road. Many recognize it as the place where cows could once be seen grazing on the spacious grounds or where pancake breakfasts were often held. Construction began in 1968 on the building meant to serve as a novitiate for incoming sisters as well as a residence for retired sisters. Changes resulting from the Second Vatican Council gave lay parishioners a more prominent place in the life of the church, and the number of formal religious vocations dropped. Recognizing that drop, the sisters realized the facility could better serve as a retreat center where all people could come to grow in faith. The center began its life as a retreat center in 1969 and has welcomed people from nearly all ages, backgrounds, and nationalities over the following decades. (Both, Pallottine Renewal Center.)

Pallottine Renewal Center is a ministry of the Pallottine Missionary Sisters, an order of Roman Catholic religious sisters founded by St. Vincent Pallotti. Pictured at left is Sr. Perpetua Moellering, who was instrumental in bringing the center to Old Jamestown. Sister Perpetua's family lived in the area and assisted with finding the property and arranging the construction. The below photograph shows how the Pallottine building looks like an angel from above. In the front is the round chapel; the middle building contains the meeting rooms, dining room, and bedrooms; and in the back is the gymnasium with the indoor pool beneath it (on the first floor). (Both, Pallottine Renewal Center.)

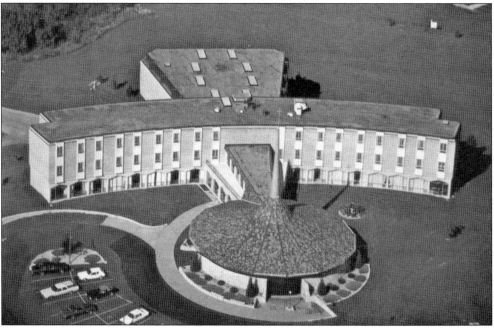

The above photograph is of Lambert and Alma Behlmann at the annual Friends of Pallottine gala. Lambert was a member of the large Behlmann family, which included Lee, Al, Mark Sr., and Mark Jr., who not only supported Pallottine fundraisers but used their construction expertise to assist with building projects. Pictured below are Pallottine board member Peggy Kruse and John Cook. John and his wife, Evelyn, were supporters and volunteers at Pallottine from its beginnings. Evelyn was a Pallottine quilter, and as active leaders of the Friends of Pallottine, they worked at pancake breakfasts and other social and fundraising events. (Both, Pallottine Renewal Center.)

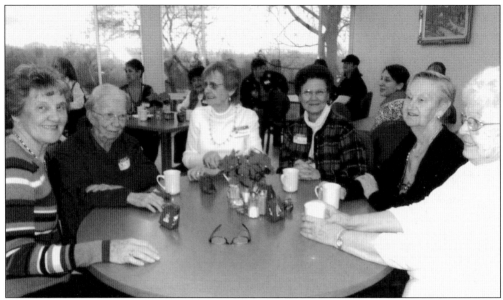

The above photograph shows members of the Pallottine Renewal Center quilter and aquacise groups at a luncheon in the dining room. Below, Jim Leighninger is talking to Santa Claus at the Pallottine Christmas Fair. On the Old Jamestown Association table are the 2017/2018 book *Old Jamestown Across the Ages: Highlights and Stories of Old Jamestown, Missouri*, and Leighninger's 2018 book *Little Creek Nature Area: A Brief History*, about the History of the Ferguson-Florissant Little Creek Wildlife Area on Dunn Road. Though the space is occasionally used for special events, Pallottine Renewal Center's primary purpose is providing a welcoming place for large or small groups to come for retreats, conferences, or other types of gatherings. (Both photographs by Peggy Kruse.)

During the COVID pandemic, Pallottine Renewal Center planted new trees along the driveway to replace aged and diseased trees. Individuals and groups contributed to the tree project, and a planting and prayer service was held. This photograph shows Linda Belcher and her son Chris Belcher, daughter Carrie Belcher Nichols, and sister-in-law Joan Belcher with the tree planted in memory of Linda's husband, Bill. The neighboring Old Halls Ferry Stable and a horse are visible in the background. Linda is a retired Rosary High School math teacher and has been leading the Pallottine aquacise prayer group for more than 12 years. Local aquacisers meet two or three mornings each week for a prayer and exercise in Pallottine's large heated indoor swimming pool on the lower level of the building. In a separate studio building, yoga classes are offered for community members. (Photograph by Peggy Kruse.)

From its inception in 1985 until the end of 2022, Jamestown New Horizons provided 42,237 hours of therapy for children with disabilities while maintaining a 100 percent safety record. It has always focused on safety, fun, and learning—in that order—while helping children to discover new friends, abilities, and horizons. The above photograph shows the "happy therapy place," Jamestown New Horizons' facility on Old Jamestown Road. Below is Trystan, a Welsh pony, enjoying his treats at the end of a lesson. (Both, Jamestown New Horizons.)

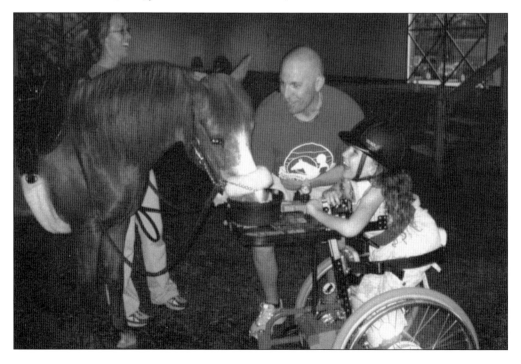

Jamestown New Horizons is a group that features a special combination of people with disabilities, dedicated volunteers, physical and occupational therapists, experienced riding instructors, and gentle horses. It was founded in 1985 to promote health and quality of life for people with a broad range of mental, physical, and emotional disabilities. In the above photograph, Grasshopper, a thoroughbred, is with his best friend for seven years. Pictured below are Jamestown New Horizons volunteers from all walks of life. Many are schoolteachers, experienced equestrians, nurses, therapists, college students, government employees, or members of the business community. (Both, Jamestown New Horizons.)

Jamestown New Horizons continues to be part of the Old Jamestown and wider community. The group walked in 17 Florissant Valley of Flowers parades (above) as well as many Thanksgiving Christmas parades in downtown St. Louis. In the below photograph, Erice, a Belgian draft horse, is with his vaulter (standing up), little Camelot, and plenty of Santa's helpers. In 1984, the North American Riding for the Handicapped Association asked Bonnie and Oliver Grueninger, owners of the Jamestown Riding School, to start a therapeutic riding center based on their safety record working with typically-developing children. Jamestown New Horizons trained 30 volunteers to serve as horse leaders and side-walkers. The horses were introduced to wheelchairs, walkers, and crutches. Various fundraisers helped provide money for insurance and a wheelchair mounting ramp. Members of American Legion Post 444 made a generous donation to help cover student scholarships. (Both, Jamestown New Horizons.)

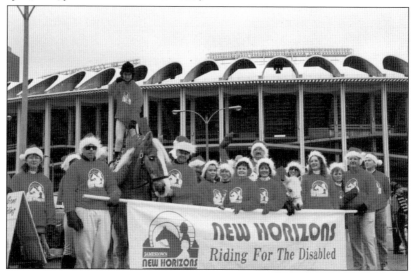

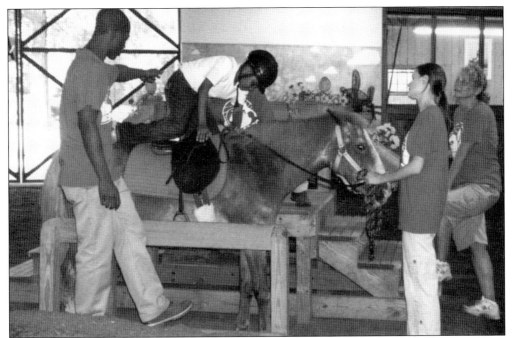

In the above photograph, a rider is mounting up on Merrywood, a Paint pony. The below picture shows a "Scarecrow" warming up on Peat Moss, the Equicizer, before his lesson begins. From the first of March until the end of November, young riders gather three days each week. It is quite a different world from special schools, clinical therapy, sheltered workshops, asphalt playgrounds, and concrete sidewalks. At Jamestown New Horizons, "the sidewalks end." As a five-year-old rider tells her mother each time they come to Jamestown New Horizons, "We are at the beautiful place." (Both, Jamestown New Horizons.)

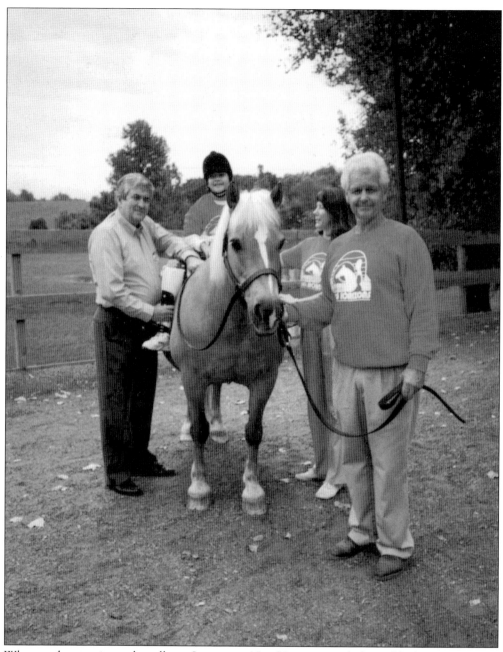

When students arrive at the valley at Jamestown New Horizons, a whole world of nature opens to them—the rolling hills, the ponds, the Canada geese, the deer, and even foxes, in addition to the horses. With classical music playing in the background, the riders are taken through a complex series of movements that consciously and unconsciously use all the body's muscles while stimulating cardiovascular conditioning. Stronger arms and legs, increased torso strength, improved balance, and greater physical endurance positively affect a disabled person's general health, decrease the likelihood of accidents or tangential illness, and can enable them to get out of the bathtub or car and be less dependent on others. Here, Quicksilver Sally, an Austrian Haflinger, is waiting for her rider to say, "Walk-on, Sally." (Jamestown New Horizons.)

Jamestown Bluffs, the 19th branch of the St. Louis County Library, opened on May 28, 1998. Named for the historic Old Jamestown area and the nearby Missouri River bluffs, the branch serves an area of the county that experienced dramatic increases in population during the 1990s. In 2015, the branch underwent extensive renovations as part of the Your Library Renewed campaign, which included the installation of additional windows, private study rooms, an interactive children's area, and a revamped community meeting room. (Both, Jamestown Bluffs Branch, St. Louis County Library.)

The above photograph shows Old Jamestown Association president Ellen Lutzow (left) presenting the 2016 Old Jamestown Association "Citizen of the Year" award to Andrea Johnson, manager of the Jamestown Bluffs Library. Below are members of the Old Jamestown Association History Committee who gave three presentations on Old Jamestown history at the Jamestown Bluffs Library. Shown are Mary Lange Stellhorn (left), who shared stories of growing up in Old Jamestown; Peggy Kruse (center), who provided some of the overall history; and Cindy Doner Winkler (right), who talked about slavery and the Civil War in Old Jamestown. Their talks were held in the library's new community meeting room. (Both, Peggy Kruse.)

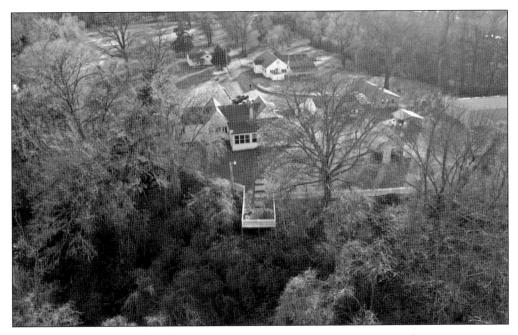

American Legion Florissant Valley Memorial Post 444, located at 17090 Old Jamestown Road, was chartered in 1946 by 77 veterans who had returned home from World War II. The post's home is located on seven and a half acres overlooking the Missouri River. It has two major buildings and several smaller buildings. The clubhouse serves as a social gathering point for members and their families. It has a large recreation room, a bar and lounge, a billiard/pool room, and a kitchen. Members spend many mornings, afternoons, and evenings in the clubhouse playing cards, pool, shuffleboard, or just enjoying good conversation and the companionship of fellow members. The clubhouse has a spectacular view of the Missouri River. (Both photographs by Chandan Mahanta.)

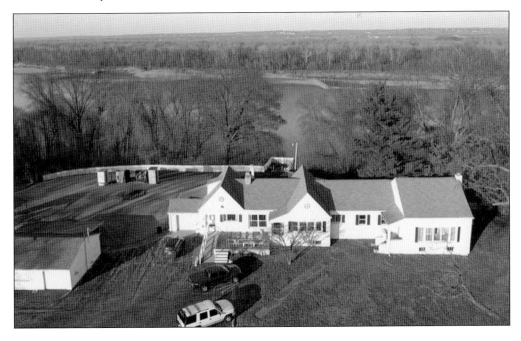

The American Legion Post 444 hall is used for meetings, social functions, fish fries, bingo, and as a rental space for weddings and other private parties. It contains a 2,500-square-foot meeting room or hall plus a kitchen, a bar, restrooms, and a storeroom. Post 444 hosts fish fries during Lent and vendor markets from March until December. A Rock the Park Benefit Concert for the Corporal Madden Foundation was held on April 22, 2023. In 2022, the first annual community fair was held on the grounds. These photographs show some of the attendees at the community fair. Attendees also formed an Old Jamestown Clean Team and signed up to collect trash quarterly on an adopted portion of Old Jamestown Road. (Both, Misty Reed.)

Boy Scouts can earn their Eagle Scout rank by living the Scout Oath and Scout Law; serving in a responsible position for at least six months; earning a total of 21 merit badges, including 13 required badges; and planning, developing, and leading others in a service project helpful to any religious institution, any school, or their community. The photograph above shows members of Boy Scout Troop 551 who assisted a fellow Scout with his Eagle Scout project of making and installing benches overlooking the river for Florissant Valley Memorial Post 444. (American Legion Florissant Valley Memorial Post 444.)

In 1951, Laclede Gas geologists were studying land formations as they sought a place to store natural gas underground. They began drilling on a promising uplift of hills on Sinks Road on property owned and farmed by Earl and Wilma Lange. When they drilled the first well, they hit oil. They knew that if it held oil, it would hold gas. Not long after the determination, Earl Lange died, and Wilma sold the property to Laclede, which named it Lange Field. Laclede holds underground leases on many acres surrounding its rustic stone service buildings at 14905 Sinks Road, and there are several working oil wells in the surrounding area. (Mary Lange Stellhorn.)

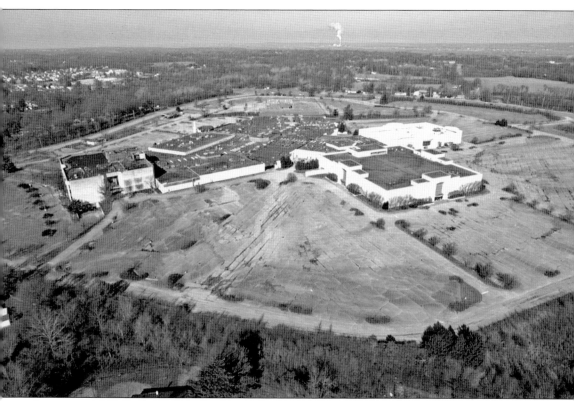

Jamestown Mall opened in 1973 on 142 acres in anticipation of residential developments moving into the area and expectations that nearby Illinois residents would provide about 50 percent of the sales. However, residential construction was limited by the karst topography, and new Illinois shopping destinations that were closer to larger populations and interstates resulted in a decline in sales. By 2009, the mall had declined, and many stores had closed. Over the years, St. Louis County worked with consultants to determine possible uses for the property. In December 2022, after public meetings and surveys, the i5Group recommended that the site become an agriculture-technology center that would include greenhouses, test plots, offices, a solar array, and possibly a grocery store, public community space and retail space. It could also provide expansion space for existing large ag-tech firms in the St. Louis area. No official decision was made, but the St. Louis County Port Authority, which owns the property, planned to solicit bids for demolition. (Photograph by Chandan Mahanta.)

In 1940, Oscar and Velma Hammer bought the Tunstall-Douglass House and 100 acres surrounding it on Old Halls Ferry Road. During World War II, Oscar was vice president of materials with Curtiss Wright Aircraft Company and later held a similar post with McDonnell Douglas Corporation. In the 1950s, the Hammers established Hammer's Farm and Old Halls Ferry Stable. After inheriting the property, their son Larry Hammer continued to operate the farm and stable until he sold them in 2018 to Old Jamestown resident Russell Inman, who now offers horse boarding as well as hayrides and bonfires for groups. While it still partially stands, the Tunstall-Douglass House was irreparably damaged in 2014 by a fire. (Below, photograph by Peggy Kruse; both, Old Halls Ferry Stable.)

El Mel, Inc., located at 6185 N. Highway 67, was started in 1961 by Elmer and Melba Wolff. Elmer grew up on the Wolff Farm at Portage and Old Jamestown Roads. Melba grew up in Baden. In an online newspaper, nocostl.com, Shannon Howard described the store as such in 2010: "The back half of the store is for lawnmower sales and service. In the front half El-Mel stocks nearly everything that chain pet stores sell. Colorful bird feeders hang from much of the ceiling, and there are two aisles devoted to wild birds. You can also find all-natural dog treats, leashes, pet toys, and premium food for cats, dogs, chickens, rabbits and even horses. During the growing season, El-Mel sells bedding plants and a wide array of seeds. Local eggs and honey are also available year-round, as are garden tools, animal traps (like for moles), and all kinds of lawn chemicals and organic soil amendments." (Photograph by Chandan Mahanta.)

Waldbart Nursery is located at 5517 North Highway 67. In 1872, Alex Waldbart and his sons began a fruit tree and flowering shrubs business in downtown St. Louis. The family successfully grew that business, relocated several times, and eventually moved into north St. Louis County. The nursery has grown from a small, one-family operation to a three-location business in two states, expanding in 1980 to Illinois, where they have a 300-acre farm. The company employs designers with bachelor's degrees in horticulture with an emphasis on landscape design and supervisors who are certified nurserymen. Baronwood Kennels (below), located at 17220 New Halls Ferry Road, was founded in 1971. It offers boarding, grooming, and training services. Brian and Terrie Bert took over ownership in 2007, live on the premises, and are very involved in the day-to-day operations. (Both photographs by Chandan Mahanta.)

Seven
EARLY AND LARGE SUBDIVISIONS

From the mid-1950s, families came farther north in search of larger lots and more green space. This photograph shows the roundabout at Old Halls Ferry and Vaile near Barrington Downs, Parc Argonne, Portland Lake, Bradford Place, and Sacre Coeur Estates subdivisions. It was built with funds that had been designated for road improvements during development. On the roundabout are native plants designed by Chandan Mahanta. (Photograph by Chandan Mahanta.)

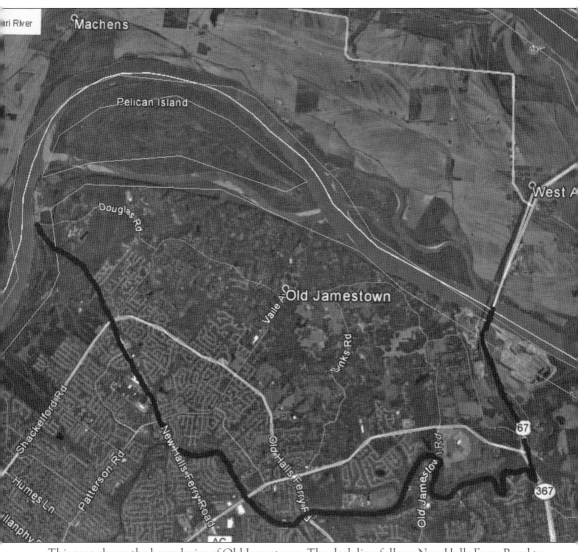

This map shows the boundaries of Old Jamestown. The dark line follows New Halls Ferry Road to Coldwater Creek (on the south) to Highway 367 to the Missouri River (on the north). Machens and West Alton are in St. Charles County. Also visible are Pelican Island and the Car of Commerce Chute, which runs between the island and Old Jamestown. In its 14.93 square miles, Old Jamestown has a diversity of residents who live comfortably and productively in subdivisions or on individual lots, all near the beauty of its natural blessings. A majority of the population over 25 has a high school or higher diploma, and 35.6 percent of residents have a bachelor's degree or higher. In 2020, the population was 19,790—an increase of 606 from 2010—living in 7,010 households. The median household income is $97,341. (Google Earth.)

The 800-acre Castlereagh Estates Subdivision was developed by Hardesty Developments, Inc., in 1956 on the former Curlee estate along the Car of Commerce Chute and the Missouri River. According to the promotion, its one- to three-acre lots offered a fabulous view of the countryside. Some residents would see Alton in the distance, and some would have a view of the Missouri River. The winding drives and wooded areas give full advantage of the scenic loveliness to each setting. The lots were "out far enough" to be away from the turmoil, yet "not too far" to get anywhere quickly—the subdivision was 45 minutes from downtown and 35 minutes from Clayton. The subdivision, which fronts Old Jamestown Road, offered concrete roads, water and electric, school transportation, and sensible restrictions. Later, there would be issues about the sewer system and whether residents could own horses, but Castlereagh Estates remains a beautiful location in St. Louis County. Hardesty also developed Fontainebleau Estates across Old Jamestown from Castlereagh and Westwood Estates adjoining it. (Photograph by Chandan Mahanta.)

Parc Argonne Subdivision on Highway 67 was developed in 1969 by Albert J. and Mark A. Behlmann Assoc., Ltd. Their promotions promised full brick and Monsanto vinyl siding, underground wiring, an open park area, and AAA schools. It was convenient to shopping and churches. In 1988, the 900-lot Barrington Downs subdivision, located at New Halls Ferry and Shackelford Roads, held its grand opening. Developed by Mason Homes, Barrington Downs had the participation of six builders offering homes in six distinctive price ranges, from the low $90,000s to the mid $200,000s for single-family homes. Condominiums were available starting at $78,900. The builders were Coppenbarger-Glosier Homes, Lieberman Homes, Mason Homes, Mayer Homes, McBride & Son, and Taylor-Morley-Simon. A planned commercial/retail center never materialized. (Both photographs by Chandan Mahanta.)

Eight

OLD JAMESTOWN ASSOCIATION

The Old Jamestown Association was incorporated in 1942. It was inactive from 1963 until 1987, when it was reactivated to prevent unsuitable development in the karst area. Ken Smith was president for 24 years and very competently coordinated with the St. Louis County Planning Department for the association's goals. In May 2008, the association awarded Smith with an acknowledgement of his years of service and efforts leading to the implementation of the Karst Protection zoning district. (Photograph by Peggy Kruse.)

In 1987, residents were concerned that they were not being included on the St. Louis County "New Jamestown" Area Study committee. Assisted by Gaynor and Jane Blake, who had participated in forming the original Old Jamestown Association in 1942, Jack and Loretta Becker and Ken and Olga Smith (above) reactivated the association, and Ken became the first president. Ken and his wife, Olga, were great leaders and worked tirelessly on association activities. When Ken (seated) retired as president of the association, he was succeeded by Chan Mahanta (pictured at left). (Both photographs by Peggy Kruse.)

In 2013, the Old Jamestown Association became a 501(c)(3) organization. Ellen Lutzow assisted with the complicated effort to move the association to 501(c)(3) status from the 1942 Benevolent Organization designation. Lutzow later became president of the association; she is pictured above with Rance Thomas, president of North County Churches Uniting for Racial Harmony and Justice, at the Pallottine Renewal Center's 50th anniversary celebration. The Old Jamestown Association History Committee was formed in 2011. The first meeting was held at the home of Beverly Girardier, who had long been the association historian. Pictured below from left to right are Ken Smith, Beverly Girardier, Patty Murray, Don Zykan, Chan Mahanta, and Olga Smith. Jim Leighninger, Mary Lange Stellhorn, and Cindy Doner Winkler joined the committee shortly after this picture was taken. (Both photographs by Peggy Kruse.)

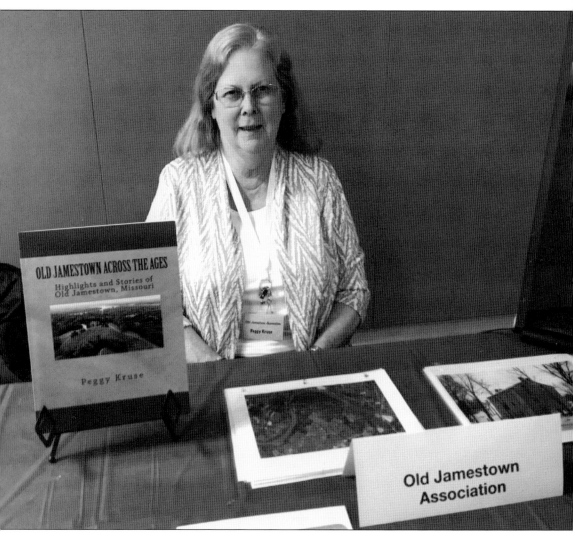

Old Jamestown Across the Ages: Highlights and Stories of Old Jamestown, Missouri, was published by Peggy Kruse in 2017. A slightly revised version followed in 2018. This photograph shows Kruse with the book at the annual Local History Fair at the main branch of the St. Louis County Library. History committee members have represented the association at many meetings and events of local historians and other organizations. *Old Jamestown Across the Ages* has an extensive bibliography and index and much more information for many—but not all—of the topics in this book. A PDF copy can be read on the Old Jamestown Association website at www.oldjamestownassociation.org. The book can also be purchased from Amazon.com or at gift shops at Historic Florissant, Inc., and Pallottine Renewal Center. (Peggy Kruse.)

INDEX

American Legion Florissant Valley Memorial Post 444, 111
Black Jack Fire Protection District, 93
Cold Water Cemetery, 23
Desloge, 77
Florissant Elks, 96
Graham, 81
Hughes, 53
James, 7, 13
Jamestown New Horizons, 104
Kohnen, 8
Laclede Gas (Spire), 114
Lange, 60
Mesker, 84
New Coldwater Burial Grounds, 25
Pallottine Renewal Center, 99
Patterson, 17
Salem Baptist Church, 26
Warren, 44
Wehmer, 72

DISCOVER THOUSANDS OF LOCAL HISTORY BOOKS FEATURING MILLIONS OF VINTAGE IMAGES

Arcadia Publishing, the leading local history publisher in the United States, is committed to making history accessible and meaningful through publishing books that celebrate and preserve the heritage of America's people and places.

Find more books like this at
www.arcadiapublishing.com

Search for your hometown history, your old stomping grounds, and even your favorite sports team.

Consistent with our mission to preserve history on a local level, this book was printed in South Carolina on American-made paper and manufactured entirely in the United States. Products carrying the accredited Forest Stewardship Council (FSC) label are printed on 100 percent FSC-certified paper.